WHITEHAVEN
IN
50
BUILDINGS

PAT DARGAN

AMBERLEY

First published 2021

Amberley Publishing, The Hill, Stroud
Gloucestershire GL5 4EP

www.amberley-books.com

Copyright © Pat Dargan, 2021

British Library Cataloguing in Publication Data.
A catalogue record for this book is available from the British Library.

ISBN 978 1 4456 9922 6 (print)
ISBN 978 1 4456 9923 3 (ebook)

Typesetting by Aura Technology and Software Services, India.
Printed in Great Britain.

Contents

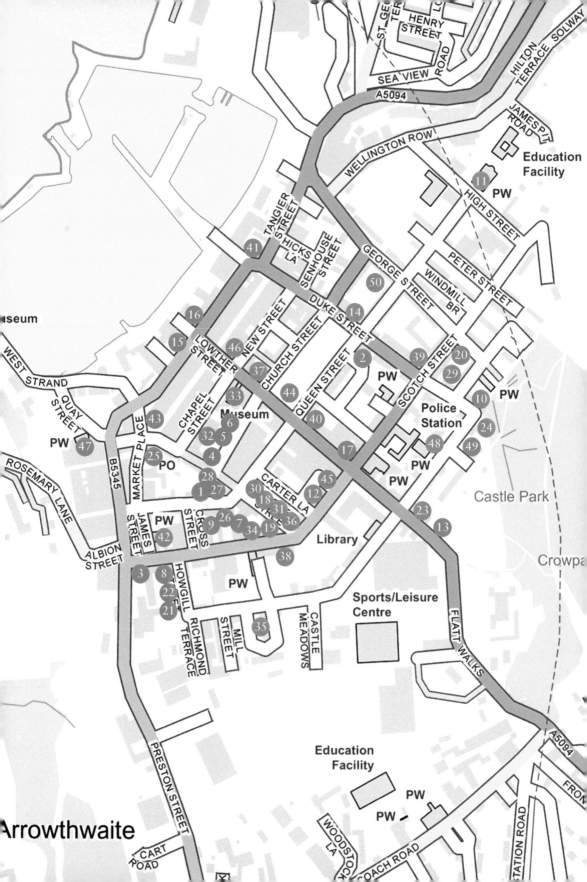

Key

1. Laal Hoose, Queen Street
2. Former Town Hall, Duke Street
3. Milham House, Irish Street
4. Town House, Church Street
5. Terraced House, Church Street
6. Narrow-fronted House, Church Street
7. Gale House, Queen Street
8. Former Assembly Rooms, Howgill Street
9. Stone Corner House, Cross Street
10. Somerset House, Duke Street
11. St James's Church, High Street
12. Double-storey House, Scotch Street
13. Whitehaven Castle, Flatt Walks
14. Corner House, Queen Street
15. Terraced House, New Lowther Street
16. Mid-terraced House, New Lowther Street
17. Clubhouse, Lowther Street
18. Mirrored House, Roper Street
19. Gabled House, Roper Street
20. Modified Terraced House, Scotch Street
21. End-of-terrace House, Howgill Street
22. Mid-terrace House, Howgill Street
23. Double-storey House, Lowther Street
24. Narrow-fronted Terraced House, Catherine Street
25. Former Golden Lion Hotel, Market Place
26. Shop and House, Queen Street
27. Dual-fronted House and Shop, Queen Street and Roper Street
28. Gothic Revival Shop, Roper Street
29. Three Tuns Pub, Duke Street
30. House and Former Shop, Roper Street
31. Refurbished Former Warehouse, Roper Street
32. Former Bonded Store, Chapel Street
33. Shop, Lowther Street
34. Italianate House, Irish Street
35. Former Catherine Mill, Catherine Mews
36. Dutch Gabled House, Roper Street
37. Trustee Savings Bank, Lowther Street
38. Italianate Building, Irish Street
39. Glass House, Duke Street
40. Former Westminster Bank, Lowther Street
41. Former Co-operative Store, Duke Street
42. United Reform Church, James's Street
43. Former Market Hall, Market Place
44. Former St Nicholas's Church, Lowther Street
45. Union Hall, Scotch Street
46. Corner Shop, Lowther Street
47. St Gregory and St Patrick's Church, Quay Street
48. Library, Catherine Street
49. Hilary Mews, Catherine Street
50. New House, Queen Street

Diagrammatic map of the historic Georgian core of Whitehaven with the position of the selected buildings indicated.

Introduction

Whitehaven is a coastal town in Cumbria, on the north-west coast of Britain, to the west of the Lake District and offers an outstanding example of twentieth-century urban conservation and regeneration. The initial settlement of Whitehaven seems to date from the medieval St Bees Priory and, following the Dissolution of the Monasteries, the small coastal village came into the ownership of Sir Christopher Lowther in 1630. Lowther decided to improve his village and he laid out the harbour in 1634 to facilitate the export of coal from his nearby coalfields. The original settlement was based around the Market Place and in around 1640 Chapel Street, King Street and Rope Street were added. In 1644 Christopher's son, Sir John Lowther, inherited the village and began an expansion programme that expanded the village into a town, so initiating the first example of a formally laid-out new town to be built in England since the extensive town-building era of the twelfth century. Lowther's town was laid out on a gridiron pattern of streets to the east of the Market Place and Whitehaven Harbour, which went on to include the lines of Lowther Street, Duke Street and George Street, as well as the cross streets of Strand Street, King Street, Church Street, Queen Street, Irish Street, Scotch Street and Catherine Street. By 1800 the town had reached its fullest extent, which today acts as the Georgian core of the town, although surprisingly no landscaped squares or similar open spaces were included.

The authorship of the Whitehaven plan is uncertain, but it is worth noting that Sir John was a London merchant during the time of Sir Christopher Wren and it may be that his town plan grid was inspired by Wren's gridiron plan for the rebuilding of London after the Great Fire of 1666. Lowther also introduced a formal rule for the development of the buildings within his new town. The house plots were to be laid out at a width of 15 feet – ideal for terraced housing, although wealthy individuals were able to purchase wider plots. Each house was required to be three storeys in height, face directly onto the street and have a long garden at the rear. The result was the establishment of a system of Georgian terraced town house blocks that lined the streets of the grid as the town expanded, although not every builder conformed to Lowther's requirements and two- and four-storey houses made an occasional appearance. In addition, the nineteenth century saw a number of Victorian church and mercantile buildings added to the town fabric. The economy of the town prospered during this period with interests in coal and shipbuilding as well as rum and sugar importing, but by the middle of the twentieth century a period of decline had set in. However, over the years the back gardens of most houses in the grid had become grossly overdeveloped,

so that by the middle of the twentieth century the historic Georgian core had become rundown and dilapidated. Despite this, while the economy of the town had declined, development did to some extent expand outwards and beyond the initial Georgian sector.

In 1972 the Whitehaven Municipal Borough Council initiated a redevelopment and conservation programme within the historic core area based on the original ideals of Sir John Lowther. This included the repair, restoration and conservation of the housing fabric where feasible, as well as the building of replacement houses where derelict conditions prevailed. The result of the programme was the regeneration of the town's intrinsic streetscape of Georgian town houses. One of the earliest streets to receive attention under the conservation plan was a section of Church Street that includes a terrace of three-storey houses, which by 1974 had been successfully restored. Following this, the regeneration programme continued successfully elsewhere across the grid until the 1980s, so that today Whitehaven can claim over 250 listed buildings, mostly Georgian in character, of which fifty are reviewed in this volume. These have been singled out by the writer as representing the most characteristic examples of the town's Georgian and later buildings, and are presented in the historical sequence in which they made their appearance, and can be seen as representing the physical aspect of Whitehaven's local history.

The terraced town houses in Church Street date from the 1730s and were the first group of houses to be successfully restored by Whitehaven Municipal Borough Council in the 1970s – a development that prompted and influenced large-scale refurbishment projects elsewhere across Whitehaven.

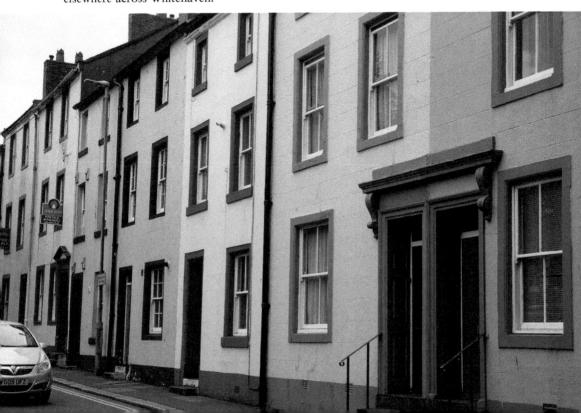

The 50 Buildings

1. Laal Hoose, Queen Street, 1698

The Laal Hoose on Queen Street is one of the oldest houses in Whitehaven and is one of a pair in a short terrace. The name 'Laal Hoose' is inscribed on a small oval name plate on the left side of the door and means 'small house' in the local Cumbria dialect. The house dates from the end of the seventeenth century according to the 1698 date marked on the top architrave. With its

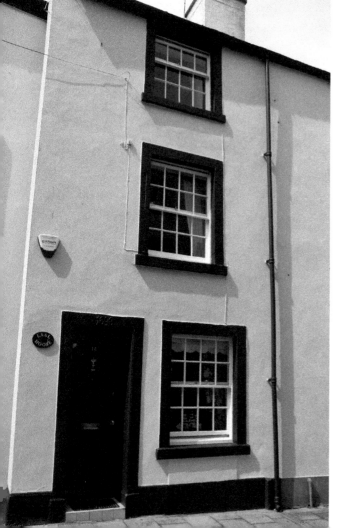

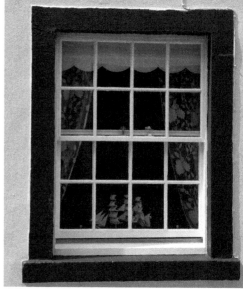

Above: The ground-floor window of Laal Hoose on Queen Street with a plain rendered architrave fits into a square opening with a pair of up and down sliding sashes and small panes.

Left: The Laal Hoose on Queen Street, with its triple storey and narrow frontage, conforms to the Lowther requirement that each house should be no more, and no less, than three storeys in height.

narrow frontage of around 15 feet and its height of three storeys, it complies with the Lowther requirements. It can thus be seen as representing a model for many of the subsequent smaller Whitehaven houses. The plain rendered front has a single window and a doorway to one side at ground level, with similar windows on the two upper floors. Both the windows and door opening are emphasised by the plain rendered architrave, while the window is set into a wide opening with up and down sliding sashes divided into small glazing panes. The small panes are representative of the Georgian character, although the Laal Hoose windows have a square rather than the distinctive vertical proportions of standard Georgian windows. Window openings, apart the street front of the Laal Hoose, represent the characteristic features of many of the Whitehaven Georgian houses.

2. Former Town Hall, Duke Street, 1708

The former Town Hall was initially built as a single house for the merchant William Feryes at the corner of Duke Street and Scotch Street in 1708. The initial building was laid out as a central three-storey block with side wings and an open courtyard, which totally departed from the Lowther requirements. In 1851 the building was purchased by the town council and was extensively renovated by

The double-storey former Town Hall on Duke Street has a projecting ground-level flat-roofed open portico and an elaborate pattern of Georgian and Venetian windows.

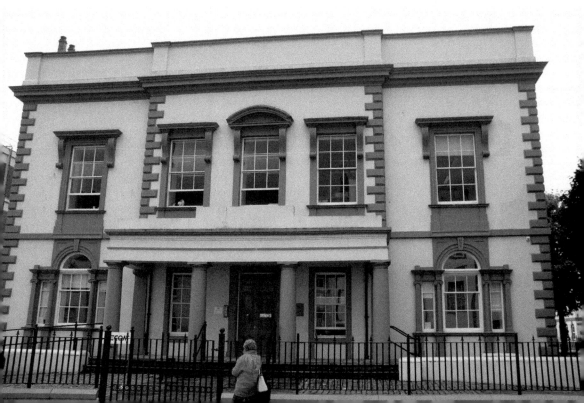

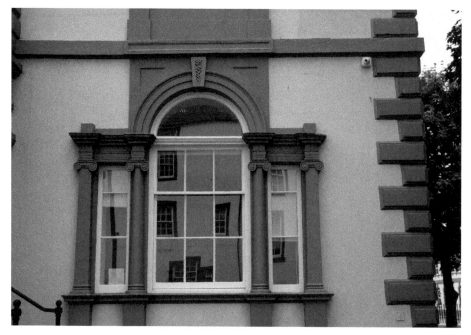

The elaborate Venetian windows on the ground floor of the former Town Hall on Duke Street have round-headed and central sashes flanked by narrow sashes – all with small panes. The sashes are spaced apart by rounded columns, decorated entablatures, or overhead beams, and a central arch over.

the architect William Barnes, in an altogether different arrangement, to act as the Town Hall. The height was reduced to two storeys and the side wings were removed. The Georgian building was subsequently used as a courthouse for some time, but is now commercial use. During this period the rendered double-storey building was given a range of standard Georgian elements including Georgian windows, corner quoin stones and a projecting front portico, which has a flat roof and four round columns. The window pattern of the house is elaborate with tripartite, or Venetian, windows at ground level and standard Georgian sash windows on the upper level. The central upper window has a curved pediment while those on either side have flat pediments – all carried on curved brackets.

3. Milham House, Irish Street, 1714

The Milham House was built by James Milham, a merchant and seaman, around 1714. This is a further example where the house layout departed from the Lowther requirements and, in an unusual instance, was set back from the street front with an open courtyard flanked by a pair of side wings that served as office and warehouse accommodation. The block also provides an end view to James's Street. There is a tradition that the Lowther family were unhappy with

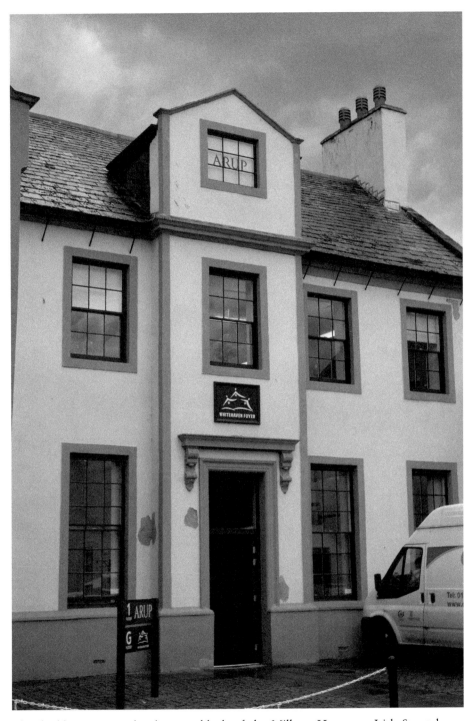

The double-storey, rendered centre block of the Milham House on Irish Street has a projecting central block and standard Georgian windows looking out over the open courtyard.

this arrangement and they introduced a requirement that all further houses in the town were to front directly onto the street. During the twentieth century the building was used as a centre for the Young Men's Christian Association (YMCA) and by the 1990s the building had become rundown. In 2009 the building was extensively refurbished and divided into the main block, and the two independent side wings and acted initially as a youth centre. Today the main symmetrical block is in commercial use. This is two storeys and rendered with a projecting central bay. This contains the entrance door with a single window over. The line of the bay is continued upwards in the form of a dormer level with an attic window. The Georgian sash windows on all levels were given plain wide architraves. The side blocks, which were originally single storey in height, and only later were amended to double storey, have their gables fronting onto the street. One is in residential use, with a Georgian window on each level and a side entrance door; each with a plain architrave. The other corner block is in retail use with a Georgian-style shop front to one side. This extends around the corner with an attractive bracketed and splayed shop doorway.

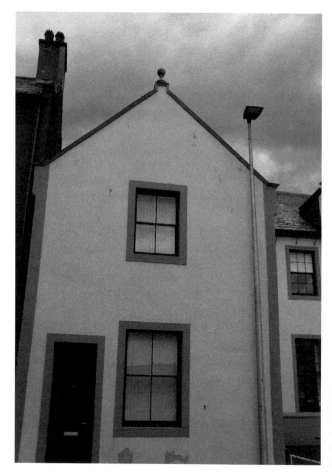

The narrow-fronted residential side block of Milham House on Irish Street has Georgian windows and a door to one side, all with plain architraves.

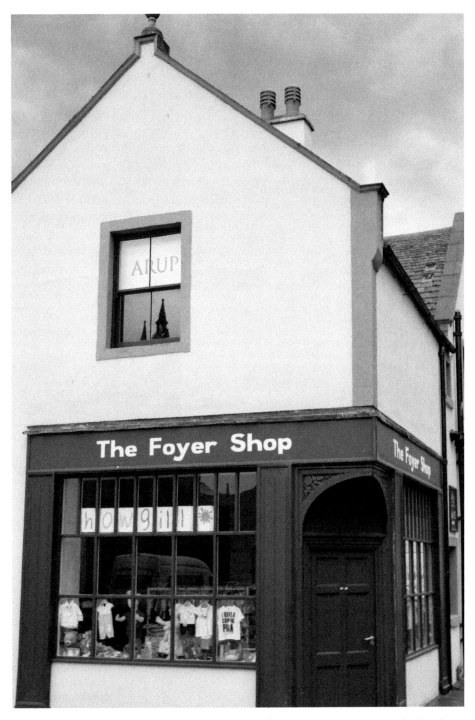

The corner side block of the Milham House on Irish Street has a Georgian-style shopfront with small glazing panes, wooden uprights, a high-level fascia, and a splayed corner door with overhead curved brackets.

4. Town House, Church Street, 1730

The town house on Church Street is one of a continuous terrace of three-storey houses with differing elevations and coloured rendering that date from the 1730s. The street elevation is irregular with a central doorway and flanking windows at ground level, three windows at first floor and a single smaller window on the top level positioned to one side. The windows have standard Georgian up and down sliding sashes and plain rendered architraves. In addition, the windows on both the ground and first level are linked with continuous string course at sill levels. The central doorcase has a panelled door and a plain fan sash set in a moulded architrave and accessed by a short flight of steps. This in turn is framed on each side by rounded columns and an overhead moulded pediment, or cornice.

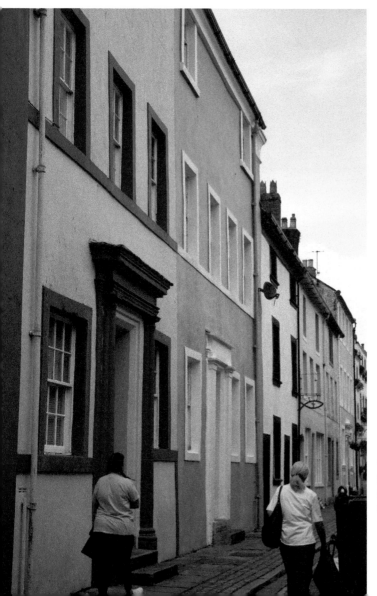

The house on Church Street is one of a continuous terrace of three-storey rendered houses.

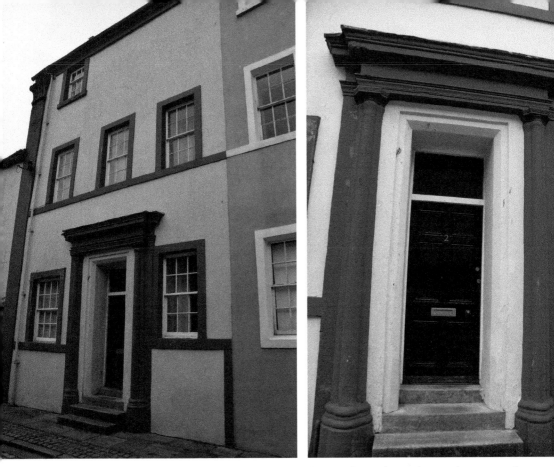

Above left: The Georgian windows of the Church Street house have plain architraves and are irregularly arranged on the different floors.

Above right: The imposing entrance to the Church Street House has a central doorcase framed with moulded and rounded surrounds.

5. Terraced House, Church Street, 1730

The wide fronted house is part of a continuous terrace of three-storey rendered houses that stretch along Church Street. The building is symmetrically arranged with a central doorcase and flanking Georgian windows at ground level, while each of the upper levels has four windows distributed equally across the front. All of the windows have standard up and down Georgian sashes set into vertically proportioned openings and framed with plain architraves. The house has a basement although the basement windows directly below the ground floor windows have been blocked off. A prominent feature of the house is the rendering which is scored in imitation of masonry blockwork. The doorway is accessed by a short flight of steps and is framed with squared side pillars and a flat moulded pediment.

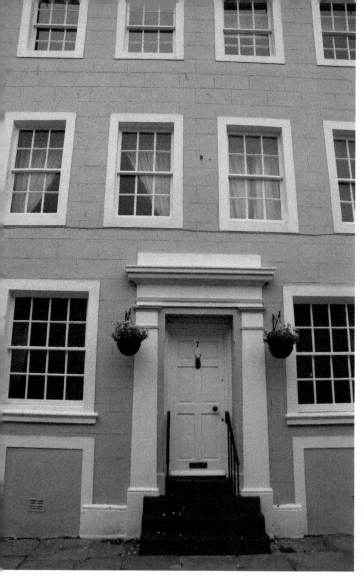

The wide house on Church Street has a range of Georgian windows, a stepped access, a framed doorcase, and inscribed masonry lines on the rendering.

6. Narrow-fronted House, Church Street, 1730

The slim house on Church Street is one of the Whitehaven houses that conformed to the Lowther requirement in relation to height and having a street frontage of 15 feet wide. The house is now linked to a number of adjoining houses that were merged together and similarly rendered, acting as a hotel. The house is three storeys high with windows of different scales on the different floors. Those on the ground and second floor are square, while the first-floor windows have vertical proportions. The sashes are divided into large panes in contrast to the more usual small Georgian panes and all are framed with plain architraves. The sheeted door to one side sits into a cambered archway that is likewise framed with a plain rendered architrave, on top of which is a rendered keystone.

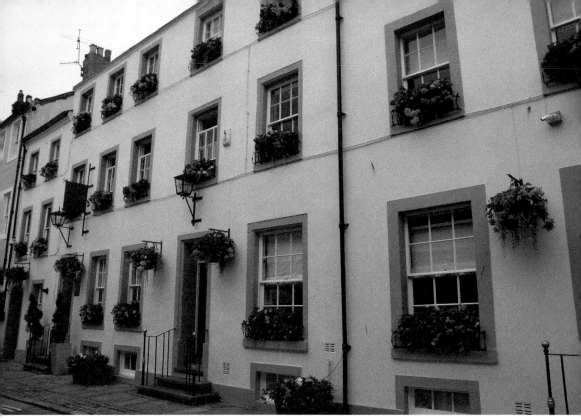

Above: The narrow house on Church Street is integrated into a continuous terrace of rendered houses that now operate as a hotel.

Right: The doorway to the narrow Church Street house is positioned on one side and, like the windows on all levels, is framed in a plain rendered architrave. The landscaped window boxes are a charming addition and match those of the adjoining hotel.

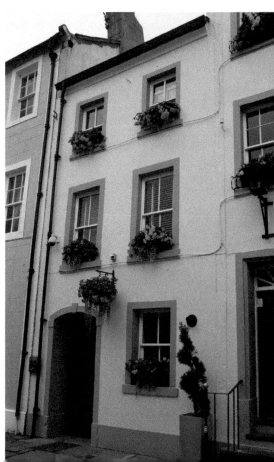

7. Gale House, Queen Street, 1733

The plaque on the front of the Gale House in Queen Street notes that the house was built by William Gale, a merchant in the Virginia tobacco trade, in 1730. The rendered double-storey house is set back a little from the street line and has a central doorway and an irregular window arrangement. The ground level has three standard Georgian windows with plain architraves: two on one side of the door and on the other side. Overhead the first floor has five similar windows arranged with slightly different spaces between. Entrance to the house is by means of a short flight of steps and side railings from the footpath. Here an unusual feature is the decorated railings that front both the house and the entrance steps. The imposing doorcase has a panelled door with an overhead rectangular fanlight. This is framed by a moulded architrave and set between squared pillars that support an overhead, slim, flat pediment. There is a second low-level doorway well over to one side of the house. This is a notable feature of a number of Whitehaven houses and provides access to the rear. This is particularly so in the case of terraced houses where no rear entrances were provided.

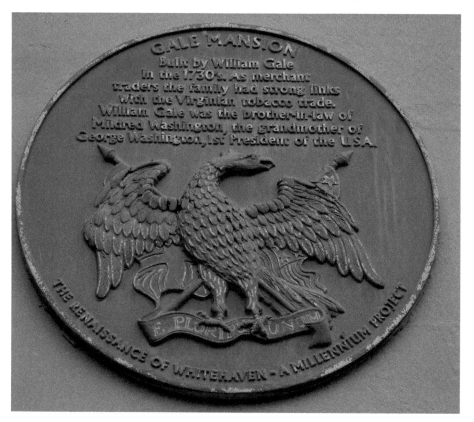

The wall-mounted plaque to the left of the entrance door provides details of William Gale, the merchant who built the house on Queen Street.

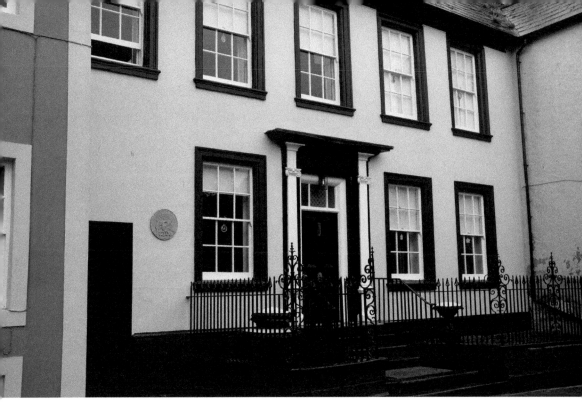

Above: The rendered Gale House on Queen Street is set back from the street line and has a central doorway and an irregular arrangement of Georgian windows.

Right: The imposing doorcase of the Gale House has a panelled door, moulded surrounds, decorated side pillars and is approached by a short flight of steps and railings.

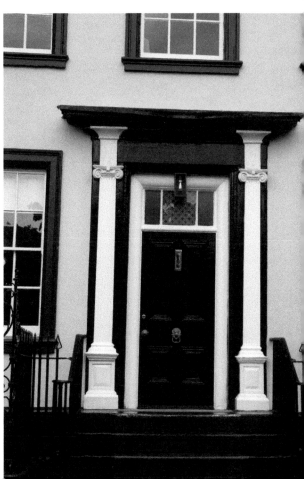

8. Former Assembly Rooms, Howgill Street, 1736

The former Assembly Rooms in Howgill Street was built by a merchant John Hayton on a double-width plot. Under Hayton's direction the rooms served as a centre for Whitehaven society during the eighteenth century for business meetings, balls, concerts and theatrical performances. The oval plaque on the front wall of the building gives a foundation date of '1736' and at the same time marks the 250 years since the foundation. In 1798 Hayton's widow sold the premises and it was subsequently used as the meeting place of the Whitehaven Scientific Association, the British Legion, a school, and as a family day centre. Today the building is currently unused and is part of an extended terrace along Howgill Street, next to the Old Brewery. It stands two storeys over a basement and is set back a little from the street line. The doorway is accessed by a sweeping double curved staircase with metal railings. The doorcase is off-centre and the panelled door is set into a slightly projecting temple front with rounded columns and an overhead triangular pediment. The doorcase is flanked by two vertically proportioned windows with plain architraves on one side and a single similar window on the other side and, although Georgian in scale, the windows have large glazing panes. Overhead the first floor has four similar windows directly over the doorway and ground-floor

The wall-mounted oval plaque celebrates the construction of the former Assembly Rooms on Howgill Street in 1736 and its 250th anniversary.

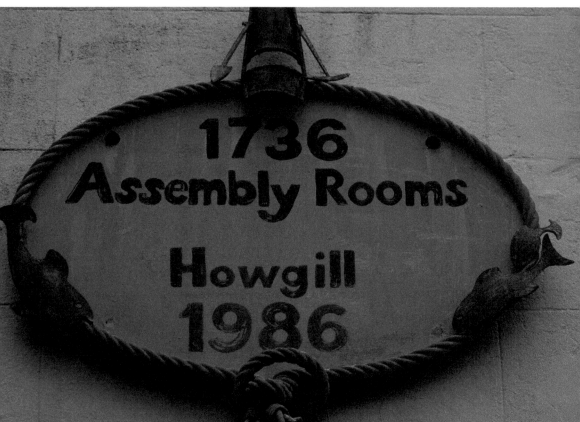

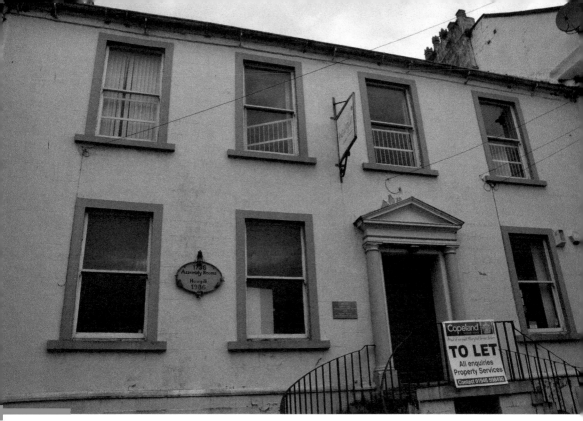

The double-storey former Assembly Rooms has an off-centre arrangement of a doorcase, double staircase and vertically proportioned windows on the ground- and first-floor levels.

windows. The window arrangement on the basement level is totally different. This consists of a low opening on each side of the staircase, each with multi-paned double sashes. An extra feature is the low doorway tucked into one corner of the basement level. Internally the building has a central staircase and a sequence of offices on each of the three floors.

9. Stone Corner House, Cross Street, 1750

In an unusual example the house on Cross Street, which dates from 1750, is faced with carefully cut and skilfully laid stonework, or ashlar. The house is positioned on the corner with Queen Street at the end of a terrace of Cross Street houses. It is the only stone-faced house in the street, although the return that faces onto Queen Street is rendered, with only a single ground-floor window. The house is three storeys over a basement with a standard symmetrical Georgian town house elevation. This includes a central doorway with a window on each side. The windows on the upper levels are arranged directly over those at ground level, although the windows gradually reduce in height on each of the upper levels. The basement windows line up with the other windows, although they project only barely above the footpath. The doorway is reached by a short flight of steps. The door itself is panelled with an overhead blank fanlight and the opening is framed in a plain architrave.

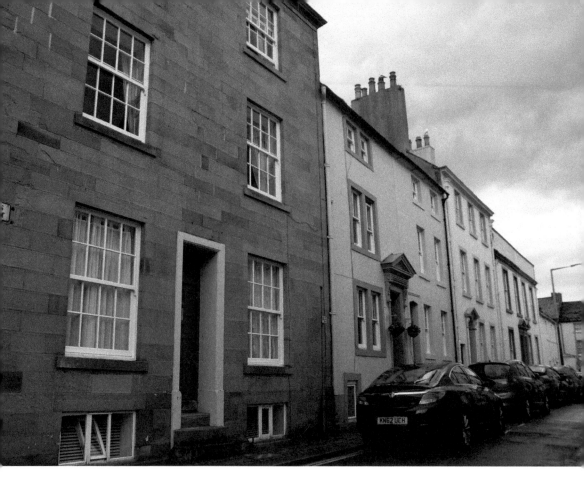

Above: The corner stone-fronted house terminates one end of the Cross Street terrace of houses.

Left: The symmetrically arranged cut stone corner house faces onto Cross Street with a central door and standard Georgian windows on each of the three levels.

The central doorway with the plain architraves is flanked on each side by standard Georgian up and down sash windows, with the tops of the basement windows projecting only slightly above the footpath level.

10. Somerset House, Duke Street, 1750

Somerset House stands at the southern end of Duke Street where it provides a closing axial vista to Catherine Street. The house was built by Samuel Martin, a tobacco merchant, in 1750 Later it was used as the offices of the Whitehaven Colliery Company and as county council offices until it was converted to apartments. The sandstone building is three storeys high with a flat stone parapet shielding the roof and a sequence of Georgian Venetian-style windows symmetrically arranged on each of the three storeys. This is one of Whitehaven's earliest houses to introduce tripartite (triple) sash windows, set into horizontally proportioned openings. These include a wide middle sash flanked on both side by narrow sashes, spaced apart by narrow stone mullions. The projecting Georgian porch at ground level is a notable feature of the house. This stands on a raised plinth with a double curved staircase and ornamental railings that provides access to the doorway. The projecting flat-roofed temple-like porch has four round columns across the front and a central triangular pediment.

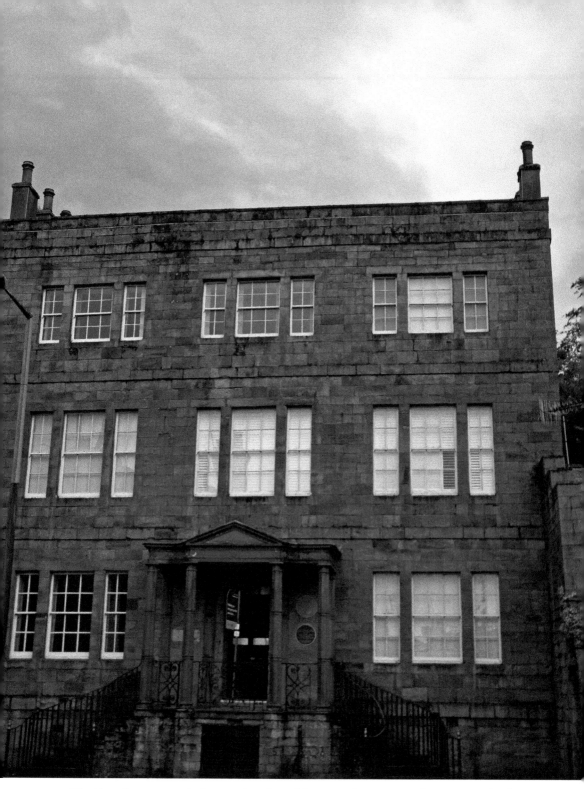

The Georgian symmetrical stone elevation of Somerset House on Duke Street marks the corner of Duke Street and acts as an end vista to Catherine Street.

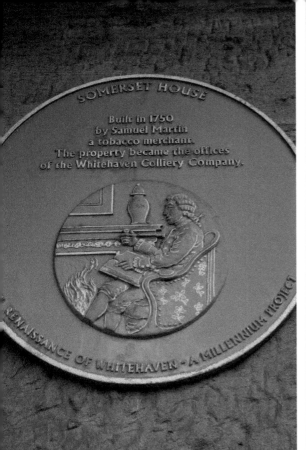
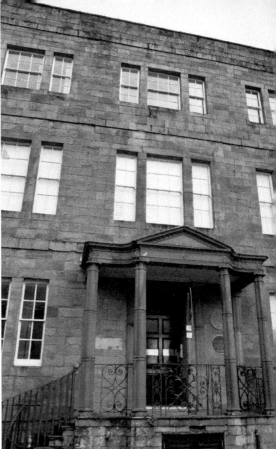

Above left: The circular plaque beside the doorway to Somerset House on Duke Street commemorates the house builder, Samuel Martin.

Above right: The projecting temple-like entrance porch to Somerset House acts as the dominant Georgian element of Somerset House.

11. St James's Church, High Street, 1752

Although strictly outside the Georgian sector of Whitehaven, the Church of St James is historically linked to the area. It is positioned on an eminence, on land donated by Sir James Lowther, where it offered an end vista to Queen Street and a view of the Whitehaven grid and fabric of the town. The Georgian church is of exceptional quality and was built in 1752. It has a double-storey nave, an elliptical apse at the rear and a central square clock tower that faces the town. The architect is uncertain as the design has been credited to both the mining engineer Carlisle Spedding and to the architect Christopher Myers. The stone central tower is divided into stages: the lower entrance level, the shaft and the parapet. The entrance level has an arched doorway with side columns and a triangular pediment, in addition to a pair of vertically proportioned windows on two levels and a triangular pediment that stretches across the full width of

the tower. Overhead the shaft has a circular clock face with a tall round-headed window over. The flat tower parapet has an arrangement of obelisk-shaped pinnacles. Elsewhere the walls of the building are rendered and have a double row of vertically proportioned windows on the front and sides, one above the other. Internally the Georgian church is equally remarkable. The entrance foyer has a double staircase that provides access to the gallery and a decorated handrail the top level that is faced by the royal coat of arms. Beyond the foyer the double-storey nave, triple-sided first-floor gallery and apse have an outstanding arrangement of rounded columns, moulded cornices, decorated arches and a richly decorated plasterwork ceiling.

The clock tower and double-height nave of the Church of St James on High Street acts as an end vista to Queen Street.

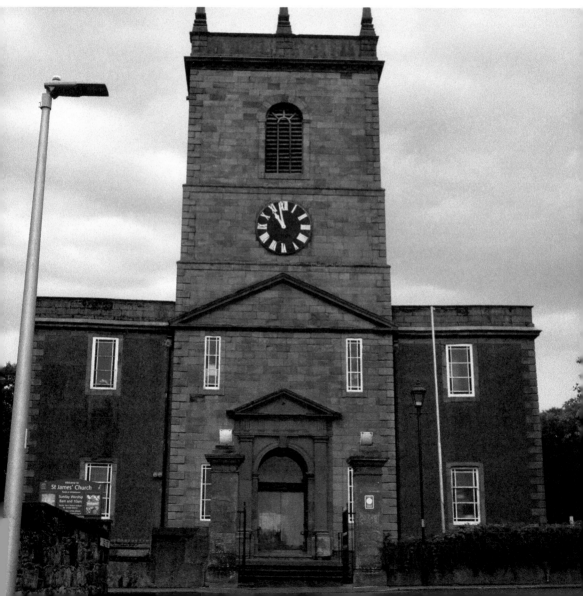

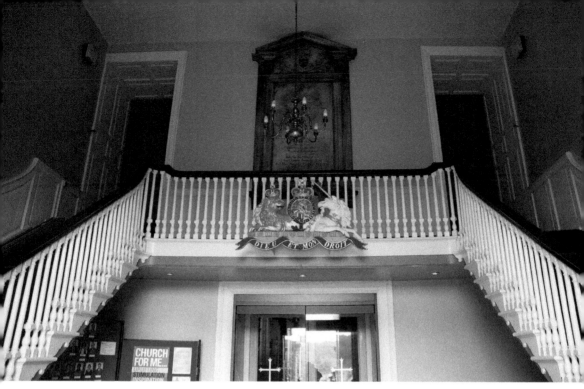

Above: The foyer of St James's Church on High Street features a double staircase that provides access to the upper gallery.

Below: The three-dimensional royal coat of arms in St James's Church on High Street looks over the entrance foyer from the upper level of the stairs.

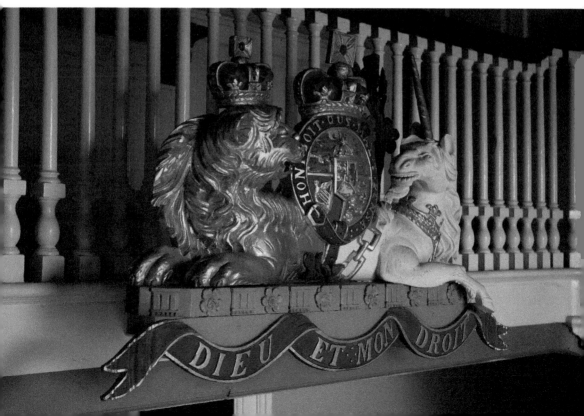

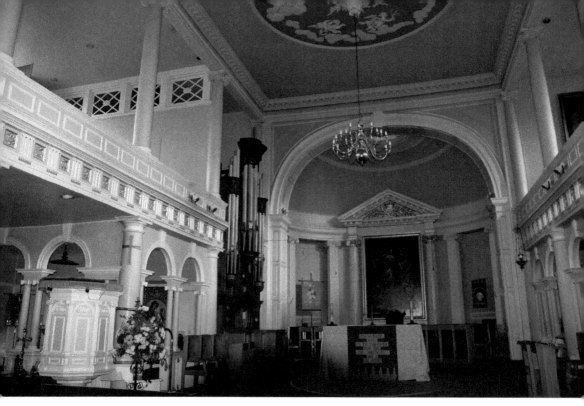

The double-height elegant interior of St James's Church features an outstanding range of Georgian structural and decorative elements.

12. Double-storey House, Scotch Street, 1730

This double-storey house on the corner of Scotch Street and Schoolhouse Lane dates from around 1730, although the current rendered Scotch Street elevation was added to the original front in 1814. This consists of a symmetrical arrangement of a central projecting bay flanked on either side by narrower bays. The central bay has an impressive doorcase with standard Georgian windows with moulded architraves on either side. These are matched by the singe windows of the side bays. The centrally positioned richly detailed doorcase is accessed by a short flight of steps and has a panelled door with a rectangular fanlight. This is framed with a moulded architrave and keystone, set between round columns with a highly decorated cornice and a triangular pediment. There is also a decorated metal railing on one side of the doorcase. A number of striking elements distinguish the building. Firstly, the rendering of the central bay is rusticated – meaning the render is applied in the form of cut stone blockwork with accentuated joints. This bay and the corners of the building have the addition of alternating rendered quoin stones. Secondly the roofline is highlighted by a balusteraded parapet that extends across the entire front of the building. The gabled side of the house on Schoolhouse Lane has a side door and two Georgian-styled windows in addition to a round-headed Venetian window on the gable that provides light to the otherwise hidden attic storey. At some period a side annex, which matches the form and style of house, was added to one side.

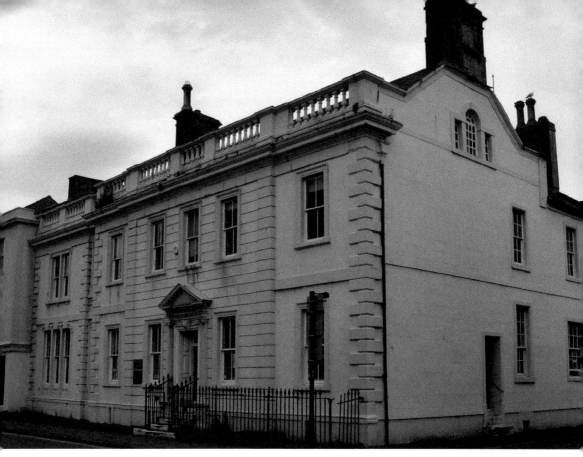

Above: The symmetrical street elevation of the Scotch Street house, with its rustication, quoins and balustraded roof pediment, dates from the 1830s.

Right: The elegant doorcase of the house has a moulded architrave and keystone, fluted round columns and an elaborate triangular pediment fronting the rusticated background.

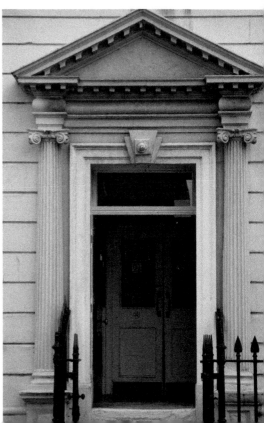

13. Whitehaven Castle, Flatt Walks, 1769

Whitehaven Castle on Flatt Walks dates from 1692 and lies at the south-east end of Lowther Street. It was owned by Sir George Fletcher and was originally known as Flatt Hall. The house and its landscaped grounds was purchased by Sir John Lowther in 1769 to act as his town house and he appointed the notable architect Robert Adam to remodel the building. The name was changed to Whitehaven Castle and Adam added rectangular corner towers and intermediate bowed turrets to the house and included standard Georgian sash windows with overhead drip mouldings on the three floor levels, in addition to rooftop battlements, to create an antique military appearance. When work on the house was completed and New Lowther Street was laid out as an extension to Lowther Street, Lowther was able to see directly from his house to the harbour. In 1924 the Lowther family sold the house and lands to Herbert Wilson who donated the building to the county as a site for the Whitehaven and West Cumberland Infirmary, which was opened in 1926. This is commemorated in the wall plaque situated near the entrance to the castle site. In 1988 hospital closed and the building was initially used as a retirement home, but was eventually converted to its present use as apartments.

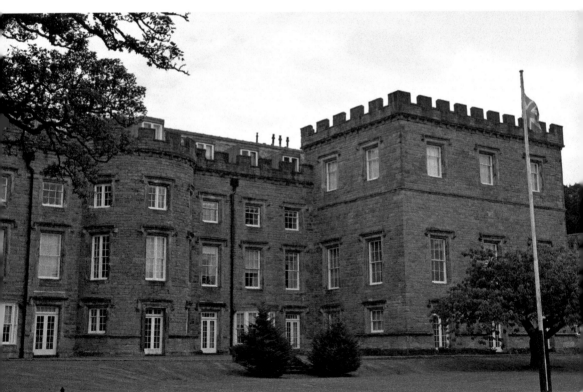

The current antique military-style character of Whitehaven Castle on Flatt Walks is the result of remodelling by the architect Robert Adam in 1769.

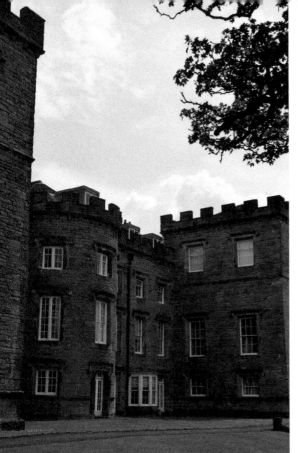
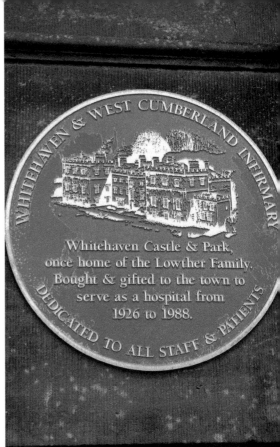

Above left: Robert Adam added corner and intermediate towers to Whitehaven Castle in addition to battlemented parapets, all enhanced by the surrounding landscape.

Above right: Wall plaque at the site entrance to Whitehaven Castle on Flatt Walks commemorates the establishing of the Whitehaven and West Cumberland Infirmary.

14. Corner House, Queen Street, 1760

This corner house is an end-of-terrace house at the junction of Queen Street and Duke Street, and dates from around 1760. Its main front faces onto Duke Street, but, in a common Whitehaven practice with corner houses, the entrance doorway is on the narrow gable end of the building that faces onto Queen Street. The three-storey Duke Street elevation has an arrangement of standard Georgian sash windows with plain architraves spaced across the width of the house front, as well as stepped quoin stones at the corners. In a common arrangement in Whitehaven, the top-floor windows are lower in height than the vertically proportioned ground- and first-floor examples. This reflects the lower ceiling height in the upper level of the house. Another common Whitehaven feature is the small low-level access doorway tucked to one side of the elevation. This provided access through the building to the rear garden of the house.

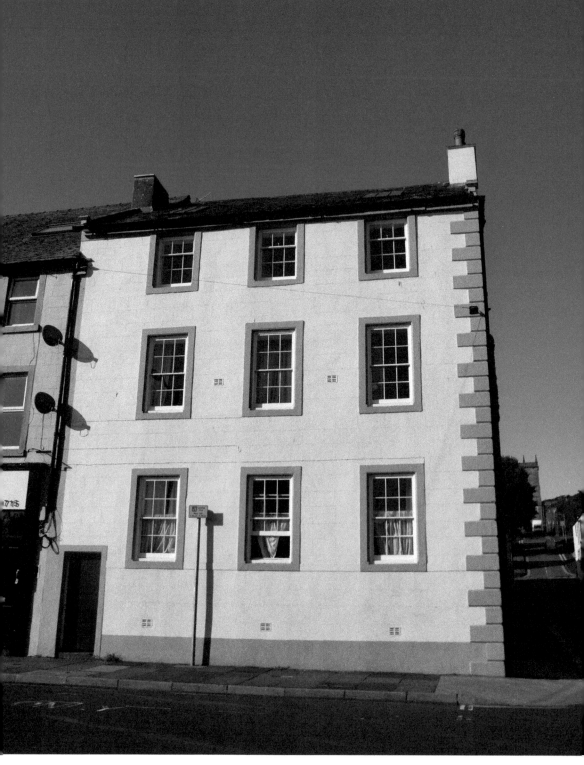

The wide triple-level elevation of the corner house that faces onto Duke Street has a sequence of Georgian windows set into the rendered front with corner quoins and inscribed masonry lines.

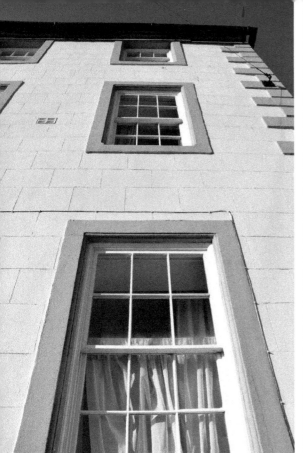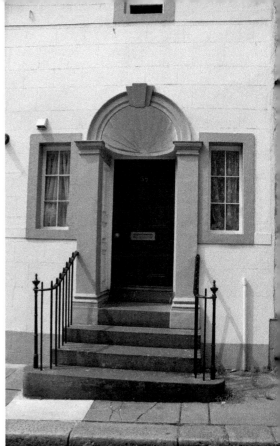

Above left: The standard Georgian sash windows of the corner house on Duke Street elevation are spaced evenly across the front, one directly above the other on each level.

Above right: The elegant doorcase of the corner house on Queen Street has stone steps, flat columns, slim side windows and a scalloped shell decoration underneath the arch.

The narrow gable on Queen Street has the doorcase to one side and narrow Georgian window on the overhead floors. The doorcase itself is impressive. This has a panelled door reached by four stone steps with a decorated metal handrail on both sides. The door is framed by flat columns flanked by slim Georgian side windows with plain architraves. Rising from the heads of the columns is a moulded semicircular shell arch with a semicircular scalloped head directly beneath.

15. Terraced House, New Lowther Street, Eighteenth Century

The Georgian town house on New Lowther Street is one of a terrace of five narrow-fronted uniformly scaled houses that stretch along one side of the street, where only the window and door designs in each house differ. There is an arrangement of similar terraced houses on the far side of the street directly opposite. The windows on each level of the three-storey house are tripartite in

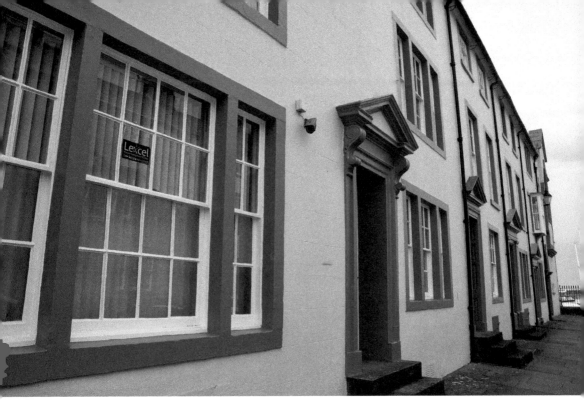

Above: The terraced house on New Lowther Street is one of five that form a terrace streetscape of similar narrow-fronted houses.

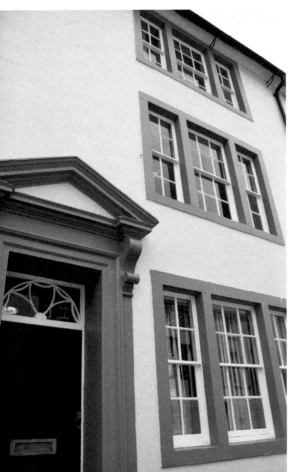

Left: The narrow-fronted three-storey Georgian terraced house on New Lowther Street has tripartite windows and a pedimented doorcase to one side.

style. The horizontally proportioned openings have a central standard up and down sliding Georgian sash that is flanked on either side by similar, but narrower, side sashes. The window is framed with a plain architrave that also divided the opening into the three individual sashes. The doorway to one side has three stone steps and a panelled door with a decorated rectangular fanlight over. This is framed by a moulded architrave, outside of which are slim columns. The head of each of the column has a projecting bracket that supports the overhead moulded triangular pediment.

16. Mid-terraced House, New Lowther Street, Eighteenth Century

The houses on the opposite side of New Lowther Street to the uniformed terraced houses (see No. 15) are similar in scale. They are three storeys high but with differing window arrangements. There is a local legend that a number of sea captains lived on the street so they could keep an eye on the ships when they were in port.

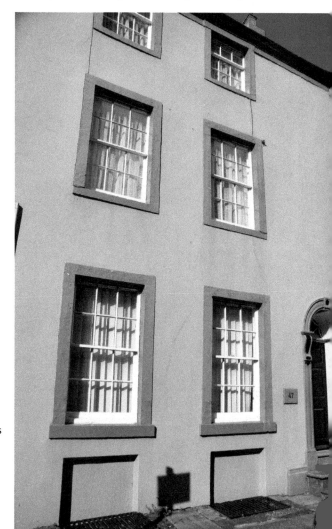

The terraced house on New Lowther Street has standard Georgian Windows side by side and immediately above one another, with the basement window openings blocked up, as well as the doorway to one side.

The house front had a doorway to one side and, in an unusual arrangement, the windows were grouped away from the doorway, with two Georgian windows on each floor – one above the other. The top window is lower than those on the lower floors, and all are framed by a plain architrave in the usual Whitehaven manner. The house has a basement with window openings located directly beneath the other windows. These are now blocked up. It is uncertain whether these were ever windows, although the metal grills in the footpath immediately outside provide light that serves the basement level. The elaborate doorcase is access by stone steps. It has a panelled door with a decorated radial-styled fanlight. The door is framed with moulded side columns and scrolled brackets carry a semicircular moulded arch, with a small keystone.

17. Clubhouse, Lowther Street, Eighteenth Century

The eighteenth-century Clubhouse house is in an end-of-terrace position on the corner of Lowther Street and Catherine Street. The two storey symmetrical building has a rusticated central bay with an elaborate doorcase, plain rendered side bays, a rusticated plinth, a moulded eaves cornice, and end quoins. The street front has a range of standard Georgian windows with moulded architraves: four at ground level and six across the upper level. The entrance to the Clubhouse

The Clubhouse on Lowther Street has a symmetrical street front with Georgian windows, end quoin stones and an elegant entrance portico.

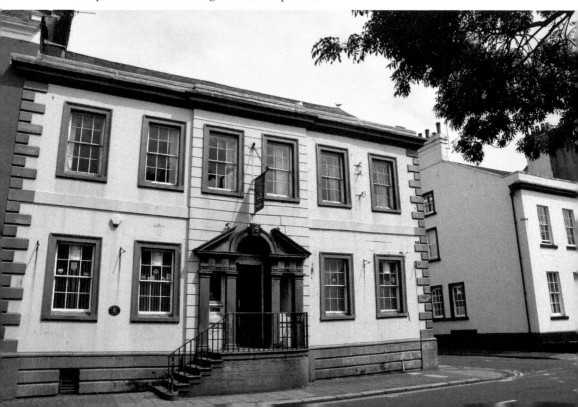

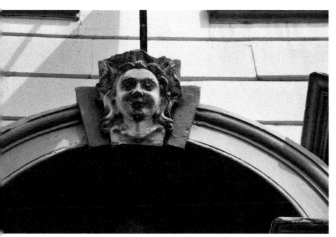

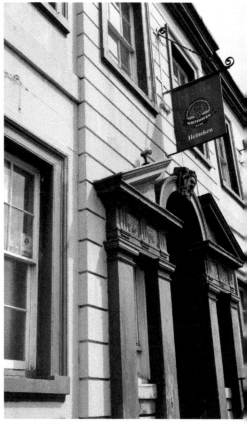

Above: The artificial Coad keystone of the Clubhouse arch is in the form of a terracotta smiling mask.

Right: The Venetian-style doorcase of the Clubhouse on Lowther Street has flat columns, an arched doorway, narrow side windows and a split pediment.

is accessed on one side by a short flight of steps and a metal handrail and is particularly elegant. The tripartite doorcase has a central door and a pair of flanking side lights set between four flat columns with a decorated cornice over the windows. The door has a blank fanlight and a semicircular arch. The latter has a keystone in the shape of a smiling classical mask that was probably supplied by the Coad firm in London. The arch is flanked on either side by a split triangular pediment.

18. Mirrored House, Roper Street, Eighteenth Centaury

The mirrored house is one of a pair of terraced town houses on Roper Street that date from the eighteenth century. The unique feature of the house is its mirrored elevational arrangement with its neighbour. This includes similar side-by-side entrances and a shared flight of six steps and matching metal handrails. The house is three storeys high with two Georgian windows with plain architraves and the side positioned entrance door on the ground level, while the upper floors have three similar windows placed directly over the ground-level door and window openings.

As is common elsewhere in Whitehaven the top windows are lower in height than the others, although in contrast to the neighbouring and more common Georgian house, the window sashes have large glazing panes. The entrance door is panelled and has a rectangular fan light with moulded jambs set between flat columns, while overhead the interior of the cambered pediment includes a three-dimensional urn.

The pair of mirrored-type houses on Roper Street has matching window and doorway arrangements.

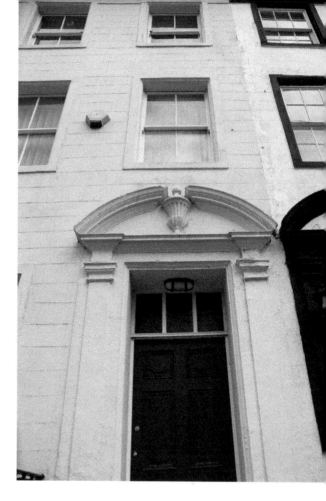

The doorcase of the mirrored house on Roper Street has panelled door, a rectangular fanlight, plain side columns and a cambered pediment featuring a stylistic urn.

19. Gabled House, Roper Street, Eighteenth Century

The gable-fronted town house on Roper Street is one of a terrace of narrow town houses that date from the eighteenth century. The house is unusual in the terrace as it was built with its hipped gable facing onto the street. That is, the gable is a mixture of a hip and a pointed gable. The elegant ground-level doorcase to one side of the house is reached by stone steps and has framed columns with brackets that support a triangular pediment, inside of which the panelled door and semicircular fanlight sits. The steps to the doorway have a metal railing that also extends across the front of the building. The window arrangement of the house, however, differs from the rest of the terrace. This has a single wide Georgian window at ground level, a pair of standard Georgian windows on the first floor and a small single Georgian window beneath the centre of the gable – all of which lack the usual architrave. The house also has a side bay with a different roof arrangement to the main house. The bay is extremely narrow, with narrow Georgian windows that appear to be on different levels to the main house. The side bay also has a small side door that provided access to the rear of the building.

Above left: The three-storey narrow gable-fronted house on Roper Street has a side positioned door and an irregular pattern of Georgian windows.

Above right: The elegant doorway of the gable house on Roper Street has a panelled door, with a semicircular radial fanlight and an open triangular pediment.

2c. Modified Terraced House, Scotch Street, Eighteenth Century

During renovation works on the houses along Scotch Street in 1975 the standard Whitehaven town house was extensively modified. This house is part of an extended terrace where all the houses had landlocked rear gardens. As part of the twentieth-century development process it was decided to provide these houses with rear entrances. To facilitate this, the modified house was remodelled to include a through driveway at ground level. This was achieved by removing the ground-floor accommodation of the house, except for the doorway and stairway at one side of the building, while at the same time the two upper floors were retained in place. This includes two Georgian windows with plain architraves on each floor. The result was the creation of a pedestrian and car archway that passed underneath the house and allows access to the rest of the houses that fronted onto Scotch Street.

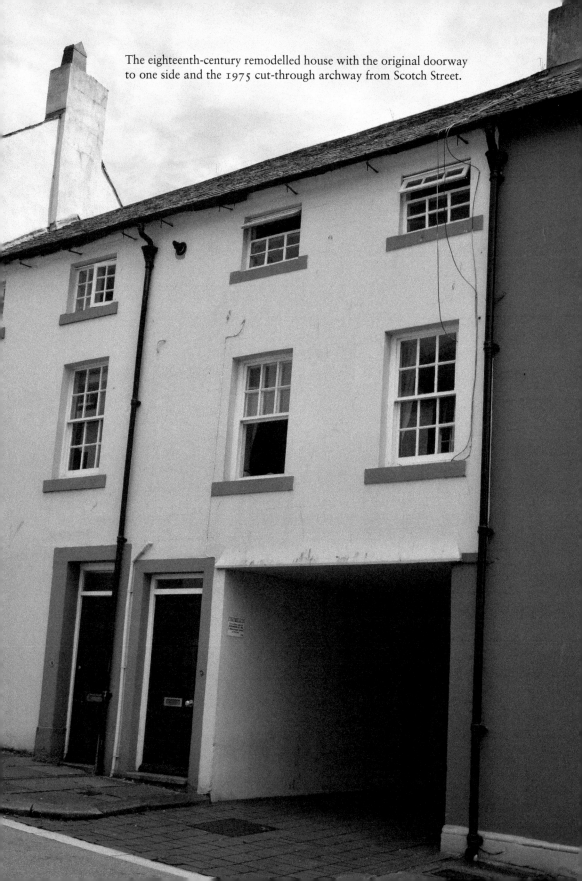

The eighteenth-century remodelled house with the original doorway to one side and the 1975 cut-through archway from Scotch Street.

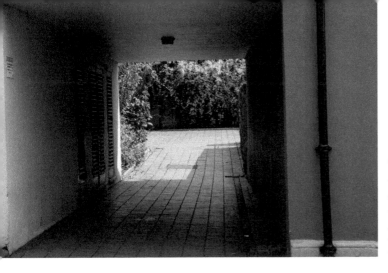

The cut-through opening of the modified house allows pedestrians and car access to the parking and rear gardens of the Scotch Street terraced houses.

21. End-of-terrace House, Howgill Street, Eighteenth Century

The end-of-terrace house on Howgill Street is one of a large number of town houses built in Whitehaven during the eighteenth century. The building is three storeys high with a partially concealed basement. The ground floor has a door to one side flanked by two standard Georgian windows with plain architraves. The doorway is accessed from the street level by stone steps and metal railings. Just

The end of terrace town house is one of a number of terraced town houses that make up the streetscape of Howgill Street.

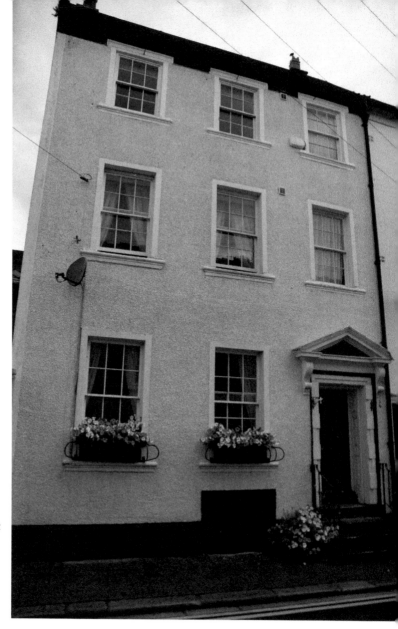

The end of terrace house on Howgill Street is three storeys high with an arrangement of standard Georgian windows on each floor as well as the doorway to one side.

above ground level is a single blocked-off opening that may represent a former window, while each of the upper levels has three equally spaced windows across the front.

22. Mid-terrace House, Howgill Street, Eighteenth Century

The mid-terraced house in Howgill Street dates from the eighteenth century and has a number of interesting and characteristic Georgian Whitehaven features. The house is three storeys high over a basement with standard Georgian windows, a

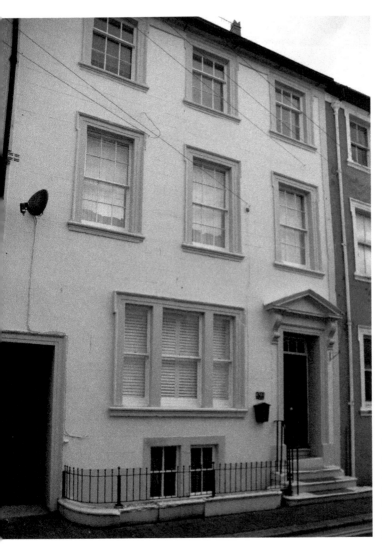

The three-storey mid-terraced house on Howgill Street presents a range of Georgian features to the street, including windows, doorways and railings.

tripartite window, basement windows, the entrance doorcase to one side and a side access doorway. The main feature of the street elevation is the tripartite window on the ground level. This has three sections. These include the middle section with a pair of large up and down sliding sashes and two similar but narrower sashes on either side. The overall window is framed with a moulded architrave and a plain millions, or uprights, that separates the three sashes from one another. Immediately underneath the tripartite window is the small basement window that sits just above ground level. This has a pair of sashes framed by a plain architrave. Overhead the house has three standard Georgian windows on each of the upper floor levels. These are spaced equally across the front and have plain architraves. The entrance at one side has a panelled door with a rectangular fanlight and flat side columns. The columns have scrolled brackets at the tops and each support a

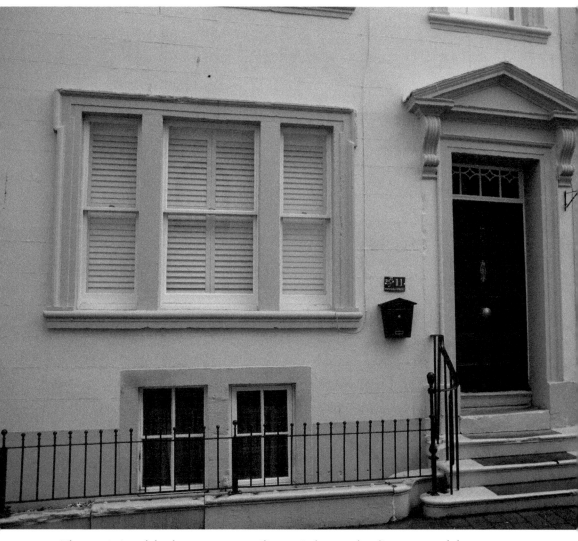

The proximity of the doorway, steps, railings, windows and pediment around the entrance to the terraced house blend remarkably well together and make a rich contribution to the Georgian streetscape of Howgill Street.

triangular pediment. The steps at the front have a metal handrail that lead to the door and continue across the front of the house. At the far side of the house is a low and discreet doorway that leads through the house to the garden at the rear.

23. Double-storey House, Lowther Street, Eighteenth Century

The individual house at the end of the terrace on Lowther Street is two storeys high with small dormer windows on the roof and is part of an interesting

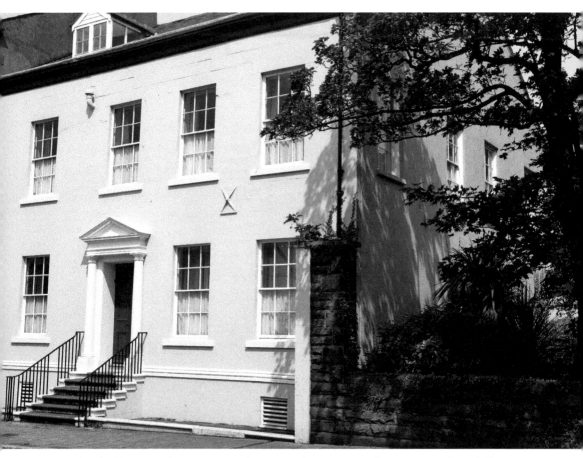

The double-storey house on Lowther Street has a range of Georgian sash and dormer windows, a raised plinth and stone steps that provide access to the entrance doorway.

streetscape. The house has a tall plain plinth and the entrance to the house is by means of a flight of stone steps with metal handrails that lead to the doorway. This has rounded columns, a moulded entablature, or cross piece, and a triangular pediment. The house has an arrangement of standard Georgian windows: three on the ground level and four on the upper level. The gable side elevation has similar Georgian windows on the upper level and that face onto Castle Park, once the landscaped grounds of Whitehaven Castle. Immediately across the street is an equally scaled house with the almost duplicate doorways facing one another. Also directly across the street and beside the second house a wall-mounted memorial commemorates the introduction of a public water supply to Whitehaven in 1859. This consists of a cast-iron rectangular wall panel with a figure to one side. The water flows from a spout and is captured in a basin, while near the ground is a second waterspout and a basin for animals. The memorial was restored in 1997 and the full-sized figure of a miner and his dog, by John McKenna, were added to one side.

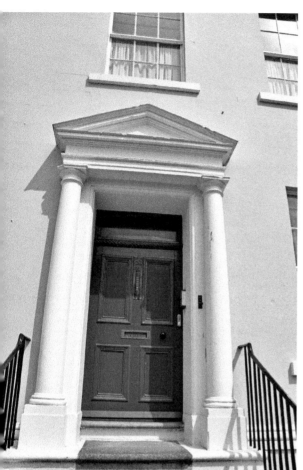
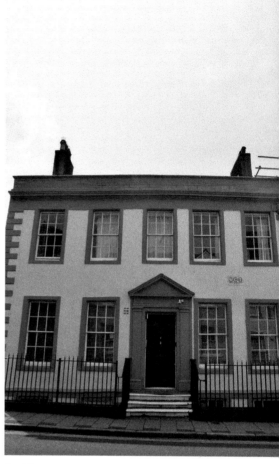

Above left: The finely executed doorcase to the double-story house on Lowther Street has rounded columns, a triangular pediment and a panelled door with a rectangular fanlight.

Above right: The double-storey house on Lowther Street and that of the house directly across the street are similar in Georgian style and form to one another.

24. Narrow-fronted Terraced House, Catherine Street, Eighteenth Century

The terraced house is one of five that make up a uniform block of terraced houses that stand at one end of Catherine Street, in addition to which the houses conform to the Lowther height and width requirements. The houses match one another in character, style and scale, and as such offer one of the few examples of a uniform housing block in Whitehaven. In another unusual feature, the houses are the only ones in Georgian Whitehaven that have an integrated front garden. The block is set back from the street line and the garden is placed between the house front and the Catherine Street footpath. The narrow-fronted house stands midway within

Above: The uniform block on Catherine Street features a row of five matching narrow-fronted terraced houses.

Below left: The narrow-fronted three-storey terraced house on Catherine Street has the doorway to one side, standard Georgian windows on the three floors, and a landscaped front garden.

Below right: The partially glazed panelled entrance door to the terraced house on Catherine Street has plain architraves and an overhead pediment carried on scrolled brackets.

the block. It is three storeys in height with the entrance door to one side. This has a rectangular fanlight and a plain architrave, as well as a flat pediment supported by a scrolled bracket at either end. A single standard Georgian sash window with its plain architrave stands beside the doorway, while the first- and second-storey windows are aligned immediately above. The ground- and first-floor windows are similar in height but, as is often the case in Whitehaven, the top window is lower. The overall scale and uniformity of the terrace is very successful, particularly when combined with the landscaping of the gardens.

25. Former Golden Lion Hotel, Market Place, Eighteenth century

The former Golden Lion Hotel, now known as Golden Lion House, dates from the eighteenth century and faces onto the Market Place, on the corner with Roper Street. The building is the most significant Georgian element of the Market Place and faces the miniature domed temple and sculpture in the centre of the landscaped triangle. The imposing former hotel is three storeys high and rendered, with a row of standard Georgian sash windows on each floor. The ends of the Market Place building have flat full-height columns and the off-centre doorcase. This is framed with rounded columns and a flat moulded pediment. Around the

The Georgian-style former Golden Lion Hotel faces a metal dome and sculpture that form the centrepiece of the Market Place.

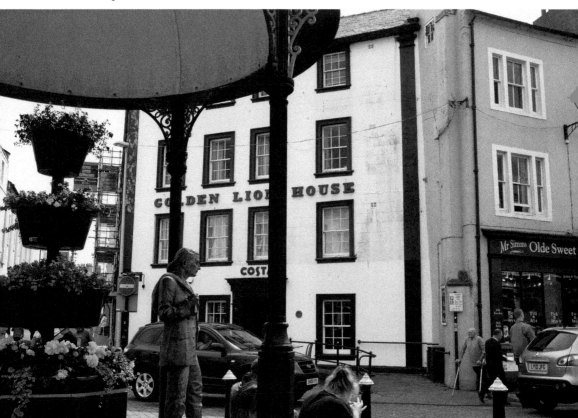

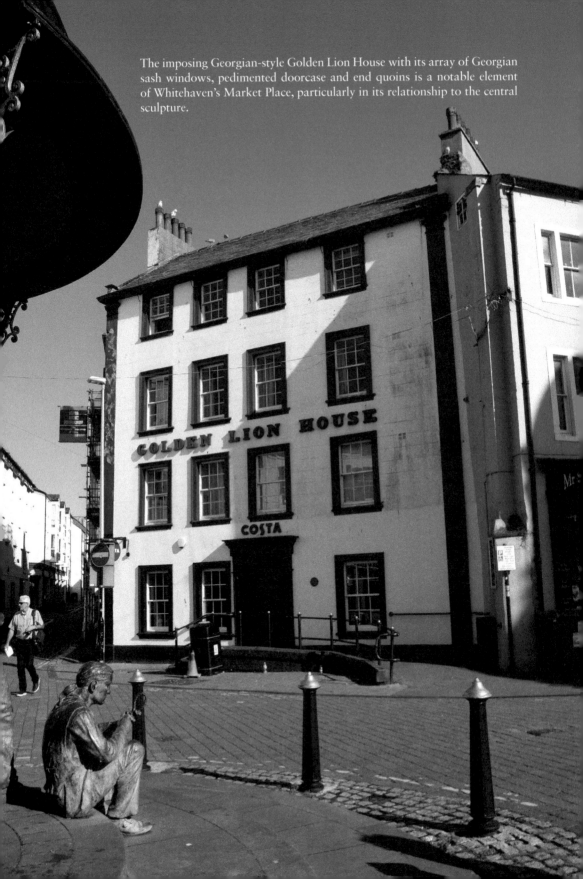

The imposing Georgian-style Golden Lion House with its array of Georgian sash windows, pedimented doorcase and end quoins is a notable element of Whitehaven's Market Place, particularly in its relationship to the central sculpture.

corner, on Roper Street, is a stone coach arch with decorated metal gates that leads to a service courtyard and building where the Georgian windows match those on the main front. The building is now in commercial use, having a coffee shop at ground level.

26. Shop and House, Queen Street, Eighteenth Century

The shop and house on Queen Street is one of a number of Whitehaven houses that were converted to retail use. The building was initially a narrow three-storey terraced house with the door to one side and a single window. The doorway had a moulded architrave and an overhead triangular pediment. The upper levels featured a pair of standard Georgian windows on each level, all with plain architraves. The conversion was achieved some time in the past by enlarging the ground-floor window and inserting a wide display window in the enlarged opening. The display window had six panes, which retained the Georgian character of the house. It also has a moulded fascia and a business name was extended across the window top. Internally the ground-floor rooms were converted to retail use. The original doorway was retained as the shop entrance and also doubled up as the access to the accommodation on the upper floors.

The house on Queen Street was converted to retail use by inserting a display window and installing an overhead fascia, while the original doorway acted as both the shop door and as access to the upper-floor levels.

27. Dual-fronted House and Shop, Queen Street and Roper Street,
 Eighteenth Century

The latter part of the eighteenth century saw a breakaway from the prevailing Georgian style and its replacement with a number of different romantic historic styles, such as the Gothic Revival, to try to create an impression that the building was of considerable age. The double-fronted corner house on Queen Street and Roper Street offers a curious example of this, with different style fronts facing the different streets. The three-storey Georgian house front on Queen Street dates from the middle of the eighteenth century with a rendered symmetrical elevation. This has a central door flanked by standard Georgian sash windows and similar

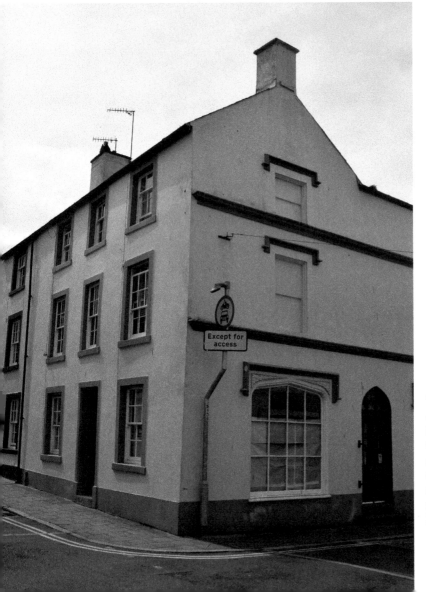

The Georgian elevation of the house front on Queen Street has a Gothic Revival style of the shopfront around the corner in Roper Street.

windows on the two upper floors. The Roper Street elevation round the corner, in contrast, was given a Gothic Revival, or antique medieval style. Here the ground floor is in retail use with a central, pointed arched shop door, flanked on each side by a Tudor-style display window and a second door to one side. The lines of the upper floors are marked with a continuous string moulding, while the Georgian proportioned windows have overhead hood moulding in the medieval manner.

28. Gothic Revival Shop, Roper Street, Eighteenth Century

The two-storey shop on Roper Street is beside the Gothic Revival elevation of the house and shop at the junction of Queen Street and Roper Street (see No. 27). This also has a Gothic Revival front and dates from the eighteenth century.

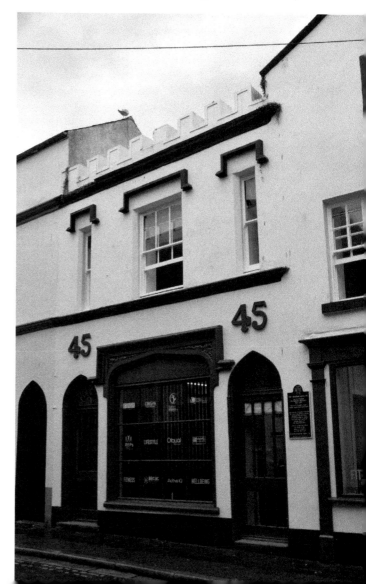

The Gothic Revival front of the Roper Street shop is visually linked to the adjoining corner building. The shop window has small-style panes set into the Tudor-style arched opening with an overhead projecting hood.

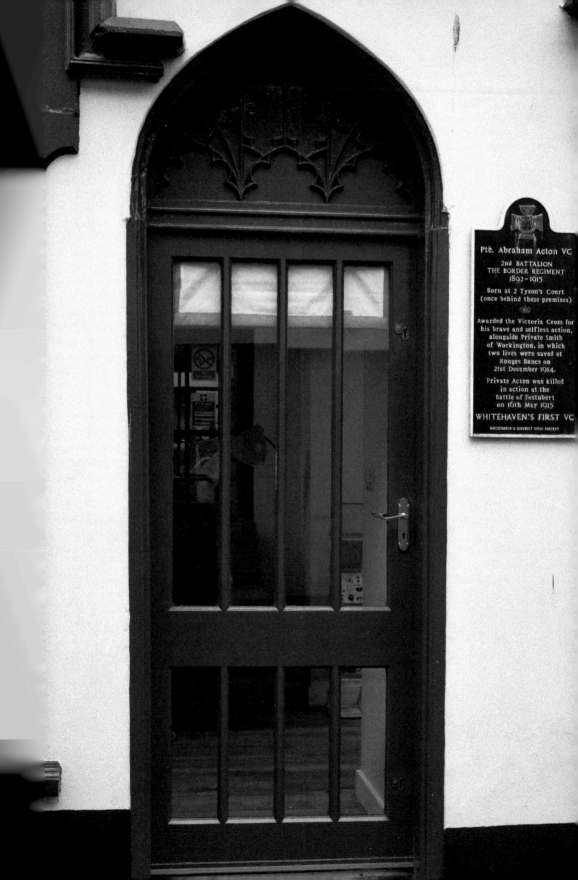

Pte. Abraham Acton VC

2nd BATTALION
THE BORDER REGIMENT
1892–1915

Born at 2 Tyson's Court
(once behind these premises)

Awarded the Victoria Cross for
his brave and selfless action,
alongside Private Smith
of Workington, in which
two lives were saved at
Rouges Bancs on
21st December 1914.

Private Acton was killed
in action at the
Battle of Festubert
on 16th May 1915

WHITEHAVEN'S FIRST VC

WHITEHAVEN & DISTRICT CIVIC SOCIETY

Right: The shopfront memorial commemorates the action and death of Private Abraham Acton of the 2nd Battalion Border regiment who was awarded the Victoria Cross in the First World War and was subsequently killed in action in 1915.

Opposite: The Gothic Revival shop door was amended when a twentieth-century-style glazed pane door replaced the original, although the Gothic Revival frame and decorated fanlight remains in position.

This elevation is complex and includes two doors and a central display window at ground level, with notable visual link between the shop building and the adjoining corner building. The Tudor arched display window is divided into small panes, with a combined fascia and moulded hood. The original doors seem to have been replaced in the past, but the pointed archways with moulded architraves survive. The first-floor level has a standard Georgian window, flanked by slim windows on either side – all three with overhead moulded hoods. A projecting string course marks the division between the ground and upper level, above which is a continuous cornice and a battelemented parapet. At one side of the building is a wall plaque memorial to the Whitehaven man, Private Abraham Action, who was awarded the Victoria Cross and was later killed in action during the First World War.

29. Three Tuns Pub, Duke Street, Eighteenth Century

The Three Tuns pub stands on the corner of Duke Street and Scotch Street. Despite the entrance being on Scotch Street, the formal address is on Duke Street. The hanging sign on Duke Street features an illustration of three tun barrels, or type of large wooden casks, for the storage of beer or wine, from which the name 'Three Tuns' is drawn. The premises began as an eighteenth-century, three-storey, end-of-terrace house on Scotch Street. This street elevation survives and has a

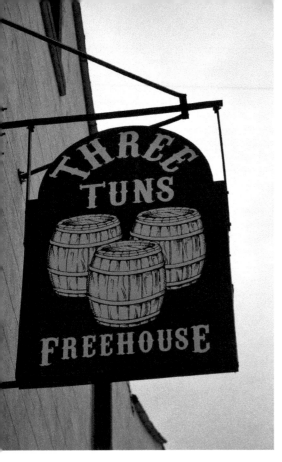

Left: The curve-topped hanging sign of the Three Tuns pub features an illustration of three tun casks.

Below: The symmetrical Scotch Street face of the Three Tuns pub features a central doorway and a range of Georgian sash windows on all three levels.

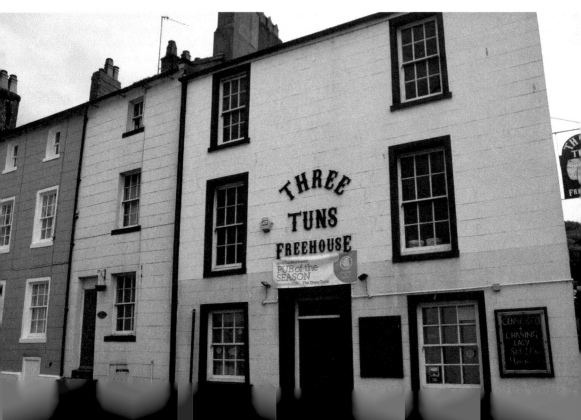

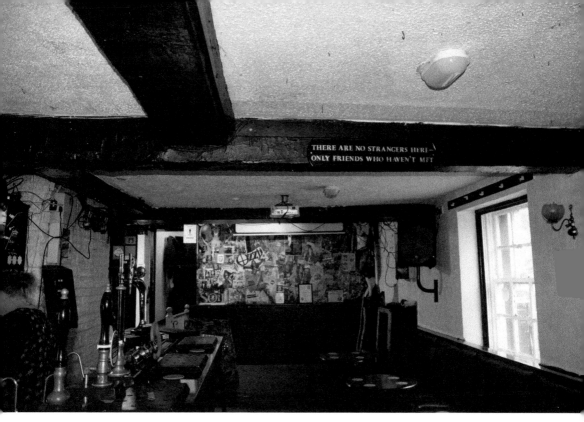

The exposed wooden ceiling beams of the Three Tuns pub supports the historic atmosphere of the interior.

central doorway flanked on either side by a single low Georgian window with a plain architrave. Overhead, the upper floors have two standard Georgian windows on each level and a central painted name sign. In addition to the hanging sign on the gable end of the house on Duke Street, the elevation features an irregular pattern of standard Georgian windows with a small attic window high up in the gable. The pub is one of the few Whitehaven Georgian buildings where access to the interior is available. Here there are two bars – one on each side of the entrance door – where the heavy ceiling beams can be appreciated. The bar also has a basement, but access to this is unavailable.

30. House and Former Shop, Roper Street, Eighteenth Century

The house and former shop on Roper Street is part of a terrace of houses that stretch along the street. The rendered three-storey house has a symmetrical street elevation that is similar in scale and form to Somerset House in Duke Street (see No. 10), particularly in relation to the window arrangement. Originally the house had a central door with a tripartite window on each side at ground level. On the two upper levels three tripartite windows extended across the street front, with a string course linking the windowsills together. The tripartite window essentially

The wide-fronted three-storey house and former shop is part of a terrace of houses that form the streetscape of Roper Street.

had a wide centre sash with a narrower sash on either side. The entire opening was framed with a plain stone architrave, with the sashes separated by similar uprights. The elevation gives the appearance of once having low-level basement windows, but these seem to have been blocked up. During the nineteenth century a shop front was inserted in part of the ground floor. The original central doorway was retained and a wide double-fronted display window with large panes and a central glazed shop door was put in place. Overhead a large stepped fascia was extended across the shop window and both doorways were provided with stone steps. Today the retail use has been discontinued and the area has reverted back to residential use.

The former shopfront on Roper Street has a Georgian-style double display window with a glazed double door, four steps and a wide-stepped fascia.

31. Refurbished Former Warehouse, Roper Street, Eighteenth Century

The refurbished former warehouse is a tall, narrow, gable-fronted building erected by James Spedding on Roper Street during the eighteenth century. The street elevation of the six-storey building has a range of window openings set into the rough, randomly laid stonework. Originally the warehouse had a series of service doors positioned in the centre of the building, one above the other, which allowed goods to be raised from street level and loaded into the various floors. Recently the warehouse has been refurbished as an apartment block with the narrow ground-level entrance door positioned on one side. The original service openings have been fitted with glazed double doors and metal railings and the original side windows of the warehouse have been replaced by casement windows. The original service doors had landing platforms, and although these have been removed, the projecting stone brackets that supported the platforms have been retained.

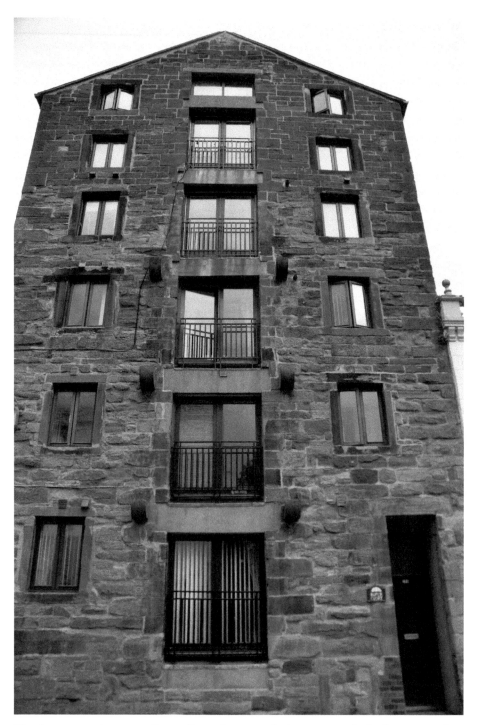

The former warehouse on Roper Street has recently been sympathetically converted to apartments where the rough stone elevation contrasts with the smooth rendered elevation of the remainder of the street.

The projecting service support brackets on the upper floors of the former Roper Street warehouse have been retained as an historic feature.

32. Former Bonded Store, Chapel Street, Eighteenth Century

The former Bonded store on Chapel Street is another example of the survival of a physical aspect of Whitehaven's industrial past. The long rectangular three-storey Bonded store was skilfully built with carefully cut stone blocks laid with fine joints and two gable-fronted bays, linked together by a central slim entrance bay. This has a narrow door at ground level with a small, barred, metal window on each of the upper floors immediately overhead. The side walls of the store, in contrast, were built with rough un-coursed masonry. Each of the gables has a wide, full-height, service doorway on each floor level – one with small barred side windows (all framed with slightly projecting stone edging). An interesting survival is the metal lifting gear beside the upper service door. This was used to facilitate the hoisting and lowering of goods between the ground and the upper floors. Another surviving feature is the storage vaulting and bottle storage lines in the basement. Unfortunately this remarkable industrial building is closed up and is currently unused.

Right: The metal lifting gear adjacent to the upper service door allowed goods to be lifted from below and swung into the various floor levels.

Opposite: The cut stone three-storey double-gabled elevation of the former Bonded Warehouse with upper and lower doors opens directly onto Chapel Street.

33. Shop, Lowther Street, c. 1785

The Lowther Street shop, formally Barclays Bank, has two floors of accommodation over the ground level and is one of a pair of elaborate three-storey, side-by-side buildings. The shop building dates from around 1785, but the elevation seems to have been amended during the nineteenth century. The ground-level rendering is rusticated with smooth render work on the upper levels. The street-level elevation has a central door flanked on either side by a wide display window and an access door to the upper levels on one side. A unique feature of the elevation is the four tall, freestanding rounded columns with decorated heads that support the continuous decorated fascia. In a unique arrangement, the shop front sits slightly behind the columns. Here the central shop door has a large rectangular fanlight with small panes, while the square-paned display windows on either side are Georgian in proportion. The intricate first-floor windows are grouped into pairs. These have narrow sashes with elaborate architraves that extend around the semicircular tops, above which a cornice extends across the building. The upper floor overhead is less elaborate. Here the individual windows are rectangular with plain architraves, above which the wide rendered parapet extends across the front of the building. Internally the ground floor is in retail use, although the former bank strong room survives as a store at the back of the shop.

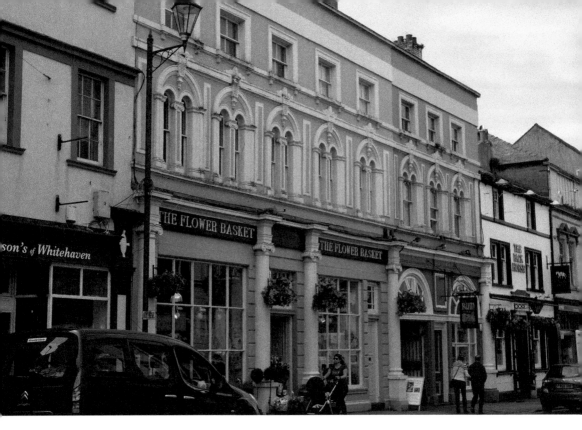

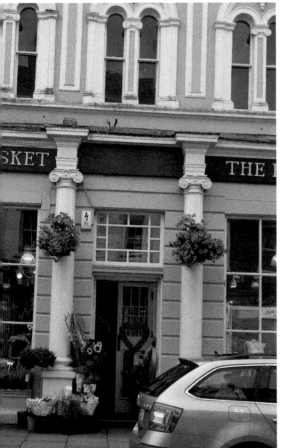

Above: The three-storey shop and house on Lowther Street has a Georgian-style shopfront and elaborately decorated round-headed first-floor windows.

Left: The doorway and Georgian shopfront of the shop and house on Lowther Street are set behind the freestanding circular columns.

34. Italianate House, Irish Street, Nineteenth Century

The Italianate house sits in a mid-terrace of uniform houses on Irish Street, built in the Italianate style in the nineteenth century. This particular style incorporates many of the Italian Renaissance or Georgian elements, but often in exaggerated forms. The Irish Street house is double storey in height over a basement with rusticated rendering at ground level and smooth rendering on the upper floor. The ground level is raised above the street level with the entrance door to one side. This is reached by seven stone steps with a decorated handrail that returns across the house front and marks the change on level between the footpath and the lower basement level. The panelled door has a rectangular fanlight, flat side columns and a flat moulded pediment. Immediately beside this the wide tripartite window has large sashes, a smooth architrave and frame, and a moulded triangular pediment on top. On the upper level the round-headed windows have a combined sill and string course that extends across the front of the house, while the plain architraves extend around the arched heads. Overhead the eaves line is marked by a moulded cornice. Beside the house is a cambered coach arch that provides access to the premises at the rear the terraced houses.

Below left: The double-storey Italianate house on Irish Street has a mixture of rusticated and plain rendering, large window sashes and decorated front railings.

Below right: The doorcase of the Italianate House on Irish Street has a panelled door, a rectangular fanlight, flat columns and a moulded pediment.

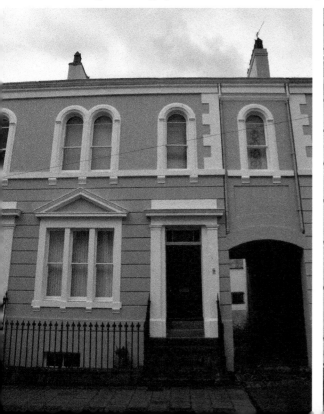
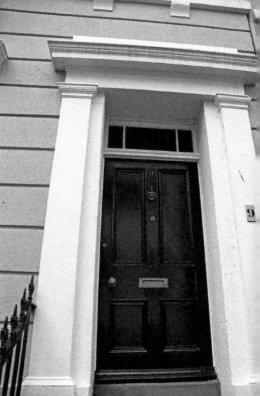

35. Former Catherine Mill, Catherine Mews, 1809

The former Catherine Mill on Catherine Mews was established in 1809 for the manufacture of linen, according to the commemorative wall plaque. The mill was established by Joseph Bell and John Brag as a fireproof flax mill, but ceased production in 1853. The building was occupied by the Royal Cumberland Militia as a barracks in 1867 and was subsequently used as floor mill, clothing factory and a warehouse. As a result of military involvement the building is often referred to as the 'Barrack Mill', and on one side of the building is a nineteenth-century artillery piece that acts as a link to the building's military connection. In 1992 the Two Castle Housing Association gave new life to the complex by restoring and refurbishing the building as apartments, with the assistance of English Heritage, Copeland Borough Council. The large, rectangular, stone-built block is four storeys high with a double-storey former engine house to one side and a slightly projecting gable on the other. The camber-headed window openings have been refitted with metal Georgian-style replacement windows, although some of the ground-level windows have been replaced by apartment doors with overhead fanlights. The block is set back from Catherine Mews with attractive landscaped gardens set between the building and the edge of the street.

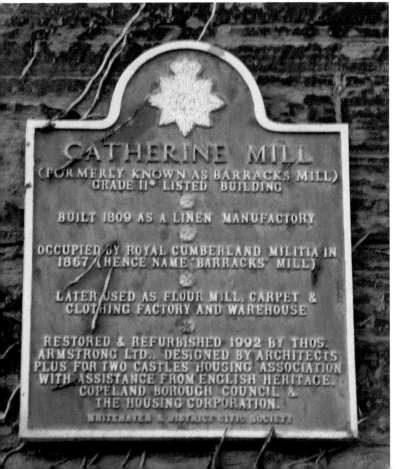

The commemorative wall plaque outlines the establishment and historic development of the Catherine Street Mill in 1809.

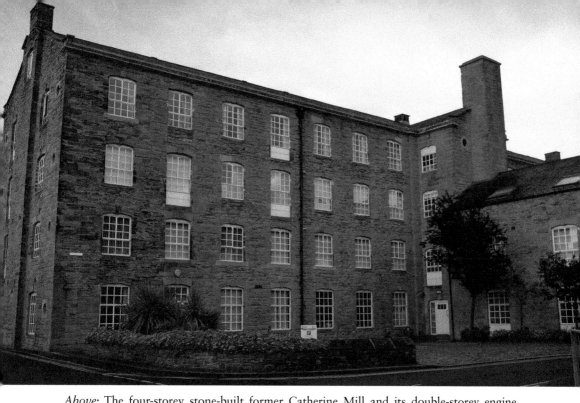

Above: The four-storey stone-built former Catherine Mill and its double-storey engine house has been recently successfully refurbished as attractive apartments.

Below: The landscaping around the sides of the former Catherine Mill give an attractive foreground and entrance to the residential and environmental quality of the building and the site.

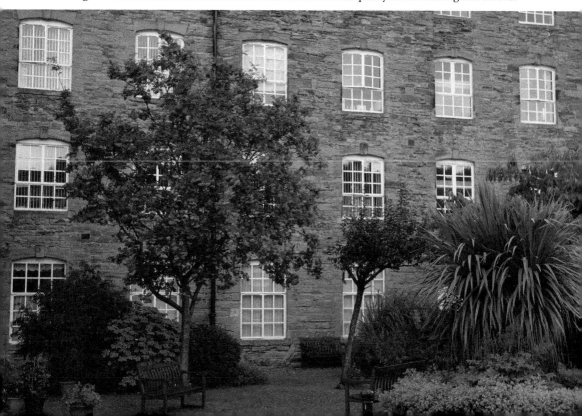

36. Dutch Gabled House, Roper Street, 1814

During the eighteenth century the Georgian architecture of a number of Whitehaven buildings was replaced by a Romantic style that sought to incorporate antique features and styles of the past – a movement often collectively referred to as Victorian. The Dutch gabled house on Roper Street was one of the early Whitehaven examples of this new style, with a design based on the gable-fronted houses of the Netherlands. The house dates from 1814 and fits into an irregular terrace of different building forms, including an adjoining former warehouse. The house has two floors and a dormer roof storey with the rendered street elevation scored to imitate cut stone masonry. The main features of the house include the double curved Dutch-style gable, with the adjoining balustraded parapet and the rounded dormer window immediately below the gable. In addition, the vertically

The Dutch gabled house forms part of an irregular terrace of buildings and sits between stone industrial buildings and the adjoining coach arch on Roper Street.

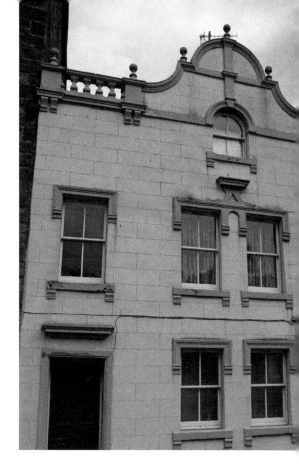

The scored elevation of the Dutch gable house on Roper Street has a double curved roof gable, balusters in addition to large pane sash windows with overhead mouldings and bracketed window sills.

proportioned windows on the ground- and first-floor levels have large panes, bracketed sills and elaborate hood mouldings, with two of the first-floor windows linked together by a continuous hood moulding. The doorway to one side is more conventional and has a moulded architrave and a flat moulder pediment.

37. Trustee Savings Bank, Lowther Street, 1833

The Trustee Savings Bank was designed by the architect Thomas Rickman on the corner of Lowther Street and New Street. The site originally held a church and during the construction of the bank vaults a number of burials were revealed. The rendered double-storey Georgian building and basement dates from 1833 and has a single-storey front portico and a sequence of Georgian windows on both floors. The open portico on Lowther Street has four columns spaced across the front with a plain entablature at roof level and an overhead decorative metal balcony railing. The upper-level Georgian windows are spaced between a sequence of flat columns that stretch across the street front, while overhead the roof is screened by a moulded parapet mounted by a centrally positioned royal coat of arms. The rendered New Street elevation around the corner is similar in design to the front elevation but lack the projecting porch.

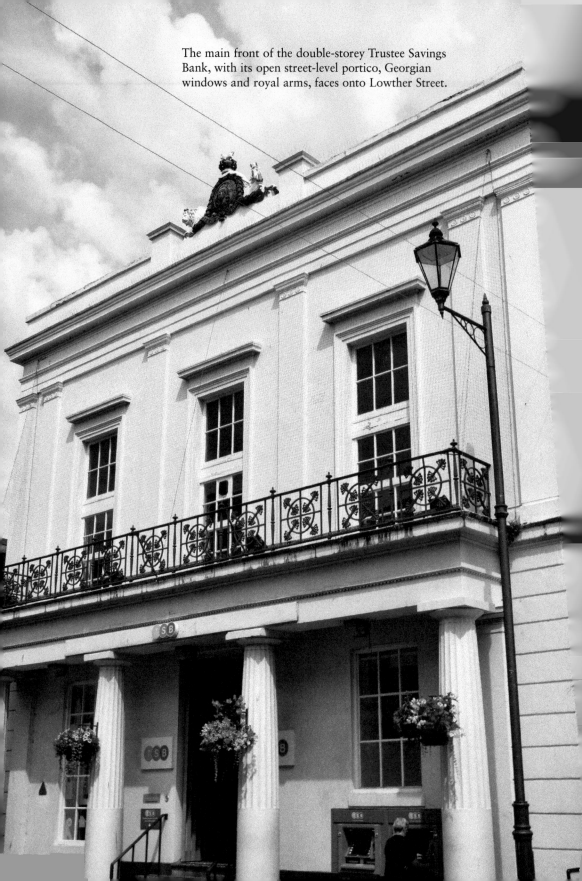

The main front of the double-storey Trustee Savings Bank, with its open street-level portico, Georgian windows and royal arms, faces onto Lowther Street.

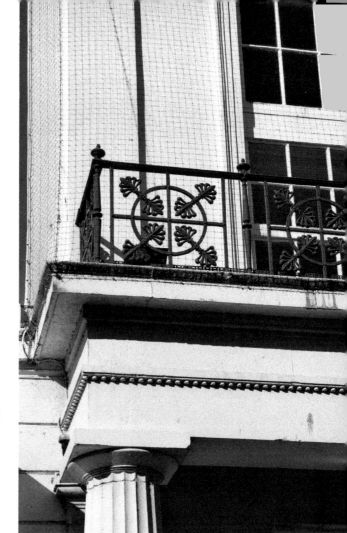

Right: The elegant portico of the Trustee Savings Bank on Lowther Street has rounded columns, a flat roof and a finely decorated balcony railing.

Below: The central point on the parapet of the Trustee Savings Bank on Lowther Street is the mounted royal coat of arms.

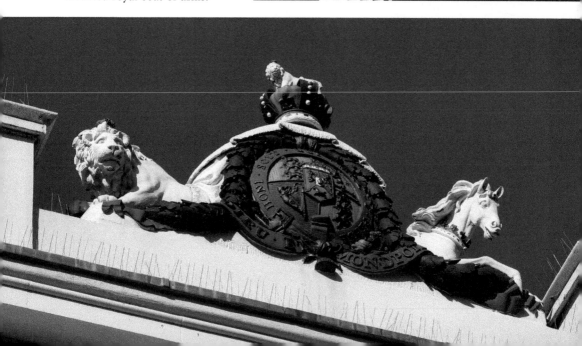

38. Italianate Building, Irish Street, 1845

The large Italianate building on Irish Street is three storeys high and part of an irregular terraced streetscape. It was built in 1845 and was designed by the noted architect Sydney Smirke in 1845. The building initially housed the offices of the Copeland Borough Council and is now in use as a medical practice. The wide and elaborate building is three storeys high with rusticated rendering at ground level and plain rendering on the upper floors, with a stone balustrading that stretches across the street front. The central double door is reached by four stone steps through a break in the balustrading. The five standard ground-floor Georgian sash windows are spaced across the front, with those on the first floor immediately overhead, although the latter are much more elaborate. These have wide moulded architraves, large triangular pedimented heads and projecting stone balconies at the bases. The top floor casement windows have moulded architraves and flat pediments, while overhead the roof is very elaborate indeed with a heavy moulded

The impressive office building and coach house on Irish Street was designed by the architect Sydney Smirke in an imposing Italianate style.

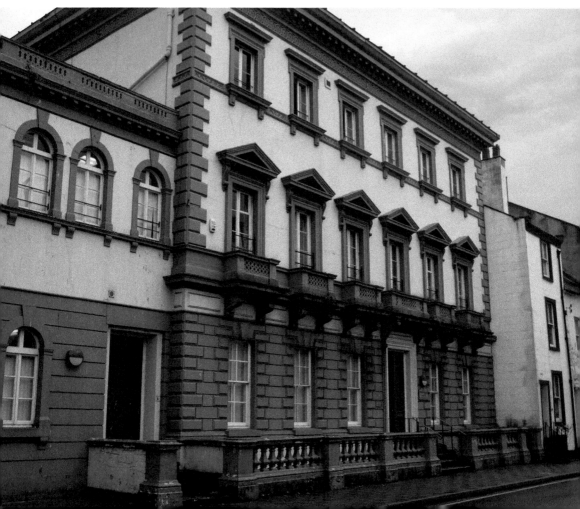

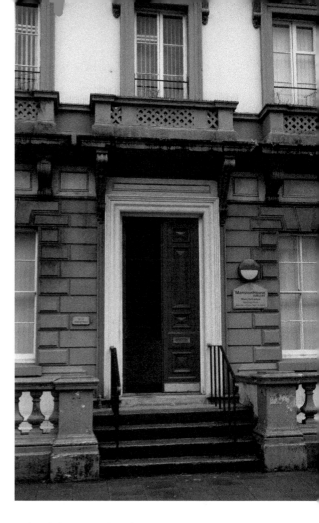

The upper-floor windows of the Italianate building on Irish Street have casement windows, moulded architraves, a balcony, and elaborate projecting eaves overhead.

cornice, brackets and a frieze. On one side of the main block the two-storey coach house has its own pedestrian street entrance and round-headed windows with plan architraves on both floors.

39. Glass House, Duke Street, 1850

The Glass House Restaurant, originally the Ship Inn, is a three-storey symmetrically arranged Georgian building that dates from 1850 and stands a little forward of the main line of the terraced houses on Duke Street. The elegant symmetrically arranged and rendered building is unusual in that it has a doorway at each side. One to serve the restaurant premises the other to provide access to the residential accommodation on the upper floors. The doorcases are similar and include plain rendered columns with rendered arches blocked out to resemble stone. The two round-headed windows are carefully positioned between the doorways, although the original sashes have been replaced by metal replacements with irregular panes. These have rendered arches to match the doorcases – all four linked together

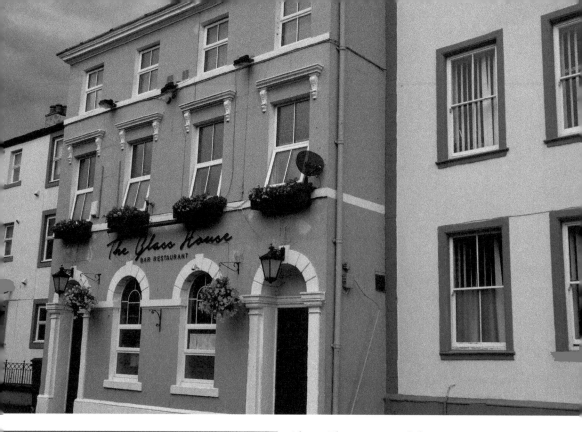

Above: The symmetrical three-storey Georgian-style Glass House building stands a little forward of the main Duke Street building line.

Left: The upper-storey windows of the Glass House building on Duke Street are aligned directly over the entrance doors and ground-floor windows.

by a continuous string course. Overhead the first-floor Georgian proportioned windows are each divided into four large panes and have flat moulded overhead pediments carried on scrolled brackets. These are aligned on the two doorways and the two ground-floor windows. On the top storey the almost-square windows, linked together by the sill line, are further aligned with the windows underneath – to complete the symmetrical arrangement.

40. Former Westminster Bank, Lowther Street, 1859

The double-storey former Westminster Bank on Lowther Street dates from 1859 and consists of an elegant Georgian corner block, with the narrow entrance elevation facing on Lowther Street and the wider side elevation on Queen Street overlooking the landscaped gardens of the Church Park. The bank vacated the premises some years ago and the building now houses the Westminster

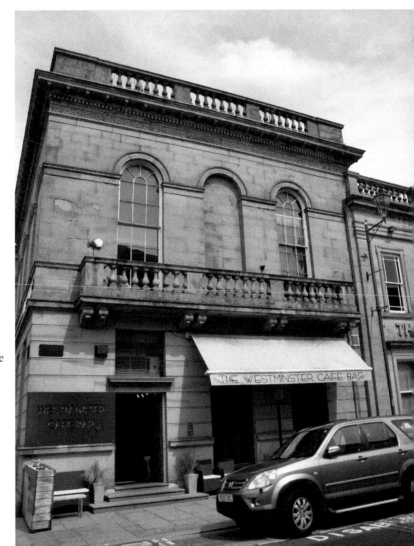

The elegant cut stone former Westminster Bank has a side entrance door, Georgian sashes, window arches and a projecting balcony that look onto Lowther Street.

Café Bar on the ground floor and business premises overhead. The window arrangements on both streets are similar with four arched Georgian windows on the Queen Street upper level and three arched openings on the Lowther Street side, although the central opening on Lowther Street is blank. The ground-floor windows are similarly Georgian but with rectangular heads. There is, however, a corner doorway on both streets. The Lowther Street door provides access to the Westminster Café Bar, while that on Queen Street leads to the stairs to the business premises on the upper floor. The ground-level windows and doors are set in rusticated masonry, while the top storey is finished in plain smooth-faced ashlar. A prominent feature of the Lowther Street face is the projecting first-floor stone balcony. This is balustrade and is carried on projecting corbels. The balcony front has a pair of string courses that continue across the full width of the building and return around the corner onto the Queen Street side. In a similar way the arches of the first-floor windows on both streets are linked together by a string course that also stretches across both fronts of the building. Overhead the roofline is marked by a continuous projecting eaves and balustraded parapet.

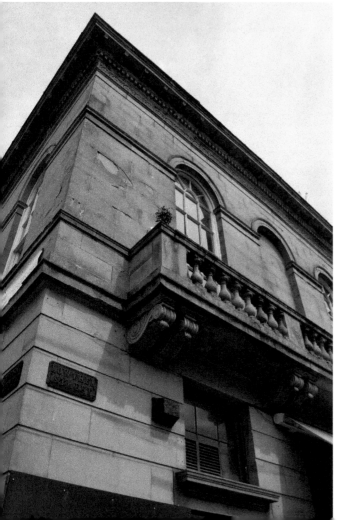

The side elevation of the former Westminster Bank features rusticated and ashlar masonry, Georgian windows, and faces onto the landscaped gardens of the Church Park.

41. Former Co-operative Store, Duke Street, 1856

The former Co-operative Society store sits on the corner of Duke Street and
Tangier Street where it also offers an end vista to the approaching Strand Street.
The building dates from 1856 and was used as a store until around 2004 and now
houses a number of commercial premises. The architecture of the three-storey
building follows a complex but loosely applied Georgian style. The ground floor,
which opens onto Duke Street, has recently installed replacement shop fronts and
a doorway set between four rusticated panels. Overhead the first and second floors
have replacement windows spaced between flat doubled columns with decorated
heads. The windows on the first floor are tall and slim with scrolled pediments,
while the top windows are considerably lower, with smaller scrolls and decorated
architraves. The roofline of the building is marked by a balustrated parapet with
a blank central panel carrying the 1856 establishing date. Overhead the central
triangular pediment features a model of a beehive – the symbol of the Co-operative
movement since 1844. Around the corner the Tangier Street elevation is similar
but without the double columns and roof pediment. The building is currently in
restaurant and retail use.

The complex Duke Street elevation of the former Co-operative store has a mixture of
Georgian elements including rusticated panels, double-height flat columns, a balustrated
parapet and a decorated triangular rooftop pediment.

42. United Reform Church, James's Street, 1856

The initial church building on the James's Street site dates from 1695. The church building was remodelled in 1856 and in 1895 the two Whitehaven Presbyterian Church congregations were merged. In around 1905 the church was remodelled and given the current Gothic Revival street elevation. The Gothic Revival style was a popular choice used across Britain during the Victorian period and the James's Street Church is one of several examples built in Whitehaven during this time. It was based on the idea of replicating the Gothic architecture of the

The front of the United Reform Church on James's Street features a range of Gothic Revival elements, including a pointed arched door and window openings, a corner tower and narrow full-height buttresses.

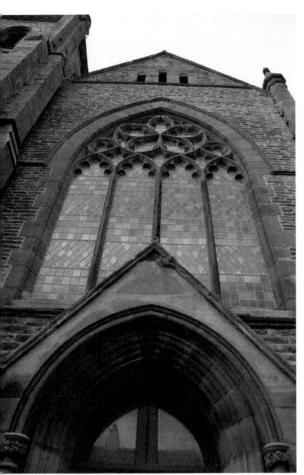
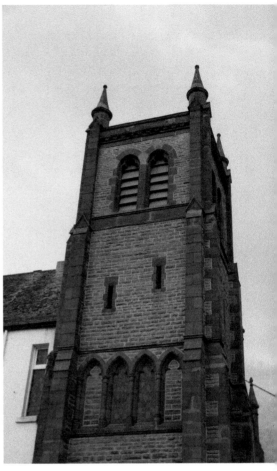

Above left: A notable feature of the main bay of the United Reform Church on James's Street is the tall Gothic Revival window with its delicate geometric tracery.

Above right: The square corner bell tower of the United Reform Church on James's Street has arched openings, stepped corner buttresses, a flat roof crowned with corner tapering finials.

medieval era through the use of heavy masonry, pointed arches, tracery, buttresses and slated gabled roofs. In 1969 the Whitehaven Congregational group merged with the James's Street Methodist congregation and adopted the name the United Reform Church. The James's Street Gothic Revival elevation has three bays, the central entrance bay, a side bay, a corner tower, with tall slim buttresses at the various corners. The main central bay has an arched entrance door flanked by small pointed windows. Above this the arched, almost full-height, window has been provided with intricate tracery. The narrow side bay has a secondary entrance door set within a moulded archway, with a traceried window directly overhead. The square corner bell tower has a further secondary arched entrance door, narrow pointed windows and arched louvers on the upper belfry level.

43. Former Market Hall, Market Place, 1881

A number of buildings completed during the Victorian period incorporated a mixture of styles, rather than that of a single antique movement. The former Market Hall in Market Place, for example, combines Georgian and Gothic Revival elements as well as twentieth-century glazing. The stand-alone hall was designed by the architect Thomas Lewis Banks and built in 1881 on the site of an earlier Market Hall. The ground floor originally held the Market Hall while the upper floor was used for public entertainment. The building was until recently used by the Whitehaven Tourist Information Office, and is now Copeland Borough Council offices. The two-storey, rendered, gable-ended building faces onto the Market Place with a splayed central bay, narrow flanking bays and a clock tower. The ground level has modern Georgian-style replacement windows, as well as a central entrance door and side door, set between columns and quoins that support a decorated fascia that extends across the front of the building. The first floor has a similar splayed arrangement of replacement windows with a large

The complex entrance elevation of the former Market Hall faces onto Market Place and incorporates a splayed bay, Georgian-style glazing, a squat clock tower and an overhead dome.

overhead medallion set into a semicircular arch. Above this is a splayed roof that carries the squat tower with a circular clock face and an overhead dome. The side elevations are altogether simpler. One has windows on the first level only, in addition to the moulded fascia continued from the entrance front and plain parapets at roof level, while the other side has casement windows on each floor set between Gothic Revival stepped buttresses.

44. Former St Nicholas's Church, Lowther Street, 1883

St Nicholas's Church on Lowther Street was another Whitehaven building completed in the Gothic Revival style. The original St Nicholas's Church was built here in 1693. This proved too small for the congregation and a new church in the Gothic Revival style was built on the same site in 1883. This was designed

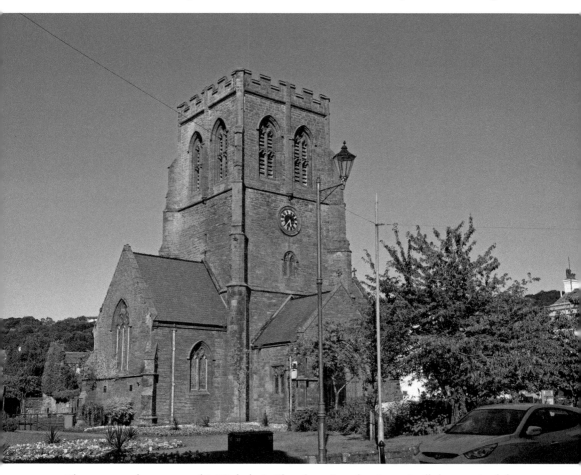

The tower and transepts of St Nicholas's Church on Lowther Street is all that survived the church fire in 1971.

The transept of St Nicholas's Church on Lowther Street survived the fire in 1971 and nowadays serves as the Tower Chapel. An interesting feature of the chapel is the crucifix over the altar table made by the welding together of the nails from the roof of the burnt-out nave.

by the architect Charles John Ferguson. Unfortunately, a fire in 1971 destroyed the building except for the tower and transepts. These surviving elements were restored and today the building acts as a community resource centre. The sandstone transepts and entrance porch have pointed arched openings and the square tower rises in three stages, divided by string courses. The belfry on the upper level has a pair of arched louvers on each side, a clock face on the west front and battlemented parapets. Internally the tower has the doorway of the 1693 building, a coffee shop, a stairway to the upper floors, access to view the clock mechanism, and a chapel in one of the transepts. Following the fire the graveyard was remodelled and relandscaped as the Church Garden. The original plan of Georgian Whitehaven did not include any formal landscaped area, so today the new Church Garden acts as a significant landscape feature of the town where it slots into the geometry of the Lowther grid. When the relandscaping arrangements were undertaken, however, the grave markers were removed, including that of Mildred Gale, grandmother of George Washington, who was buried here in 1701. For this reason the position of the grave of Washington's grandmother is unknown. One sad element of the new landscaping is a low pedestal, which stands near one end of the garden and is mounted by images of children, a pack animal and a miner. This is a memorial, erected in 1980, to the seventy-seven children who died while working down the Whitehaven coal mines during the nineteenth century, including Abraham Taylor (aged eight) and Andrew Peters (aged nine).

The revised layout of the former graveyard of St Nicholas's Church, now the Church Garden, adds a significant landscape element to Lowther's gridiron layout of Whitehaven.

The sculptured pedestal memorial in Whitehaven Church Garden is inscribed with the names of the 77 children who tragically died while working down the Whitehaven coal mines.

45. Union Hall, Scotch Street, 1880

The Union Hall at the corner of Scotch Street and Lowther Street was built in 1880 and housed the Whitehaven Poor Law Union, which administrated the Whitehaven workhouses. The rendered building is in the Italianate style, although the block seems initially to have consisted of two buildings. The corner building is three storeys high with a sequence of Georgian proportioned windows. These have large glazing panes and are edged with moulded architraves, three of which have overhead pediment. The arched ground level doorcase has rounded columns and a triangular open-based pediment. The narrow return on Lowther Street is similar, with two windows on each floor level, but lacks the gable fronts. The two-storey section of the building on the left has windows on each level. These are similar in style to the corner building except they are much larger in scale. The doorcase is also more elaborate. It has a pair of flat and rounded columns on pedestals that flank the arched doorway and a flat roof with a decorated cornice. Visually the two houses are closely linked together at roof level, so as to create the impression of a single block.

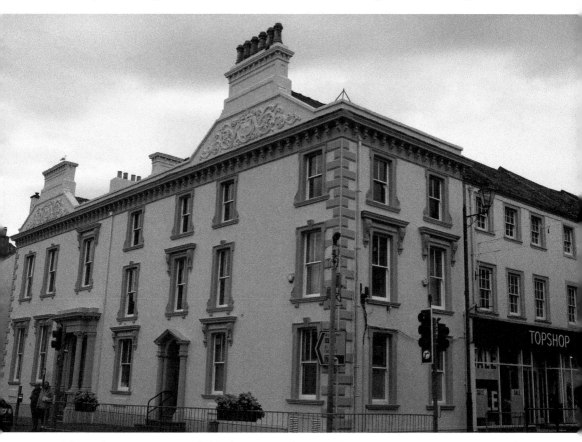

The Italianate Union Hall block on Scotch Street has an attractive arrangement of vertically proportioned windows, doorways and quoins, which extend around the corner into Lowther Street.

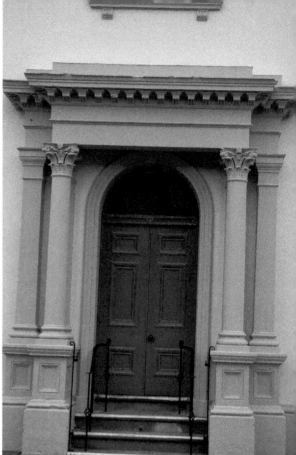

Above left: The windows of the Union Hall on Scotch Street have large sashes with moulded architraves and keystones – some with moulded pediments carried on scrolled brackets.

Above right: The elaborate and finely executed doorcase of the Union Hall on Scotch Street has a pair of flat and rounded columns on pedestals that flank the arched doorway and a flat roof with a bold and decorated cornice.

Each house has a street-facing gable end with a similar inset decorated coats of arms, along with a wide and elaborate chimney stack overhead. Underneath, the gables of the two buildings are visually linked together by a continuous heavy cornice that extends across the front of the entire block. The block has been extensively refurbished some years ago and is now in commercial use.

46. Corner Shop, Lowther Street, Nineteenth Century

The corner shop at the intersection of Lowther Street and King Street originally formed part of one of the few formal town planning features in Georgian Whitehaven, apart from the grid plan. Here the junction of the four streets was arranged in an octagonal arrangement by the splayed angle of the four corner

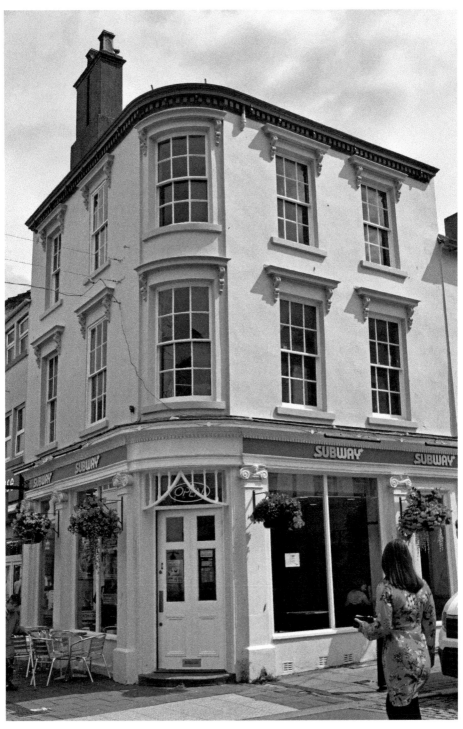

The corner shop at the junction of Lowther Street and King Street is distinguished by the entrance and Georgian elements incorporated into the corner splay.

The Lowther Street and King Street Corner Shop has the doorway, fascia and window sashes, and window openings set into the curved corner splay.

buildings. Only three of the splays survive as today, as the splay on the former Burton building was eliminated in 1933. The rendered three-storey Georgian corner shop dates from the nineteenth century and was slotted into a restricted square corner plot. The corner splay of the building features a panelled door with overhead hanging brackets at ground level, a curved fascia overhead and curved Georgian windows on the two upper floors. The full-height, wide display windows on Lowther Street and King Street are framed by flat columns that stretch up to the continuous moulded fascia, which in turn extends across the entire shop front. Above this the street elevations have a pair of standard Georgian windows on each floor level. These have flat pediments on moulded brackets, above which the roofline of the slated building is marked by a projecting cornice.

47. St Gregory and St Patrick's Church, Quay Street, 1899

The stone plaque over the doorway to St Gregory and St Patrick's Church on Quay Street was unveiled by Revd Dr Wilkinson and proclaims that the church was built in 1899. The surrounding area was once part of the oldest sector of

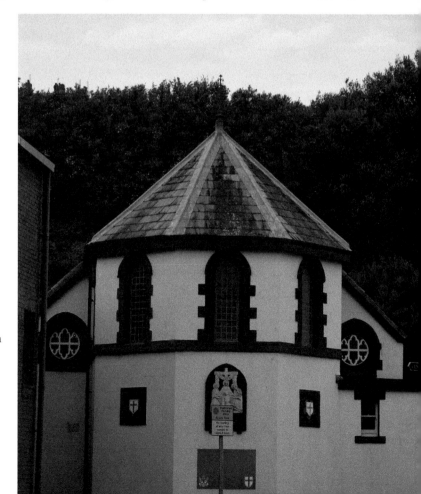

The otherwise plain rendered elevations of the apse and nave of St Gregory and St Patrick's Church on Quay Street has arrangement of arched and round windows framed with brick surrounds.

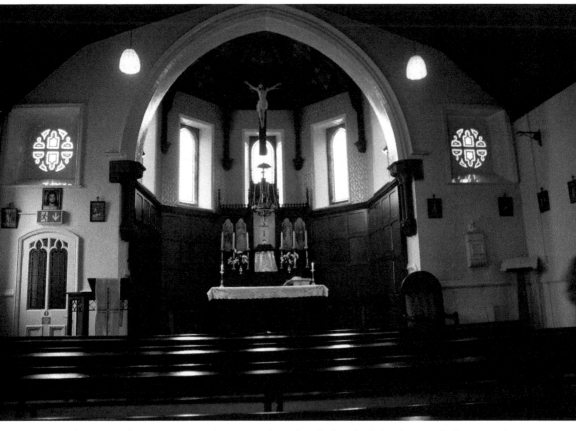

The nave of St Gregory and St Patrick's Church has high-level stained-glass circular windows, a wide sanctuary arch and the altar recessed into the apse.

Whitehaven, with many houses and streets. Unfortunately, these have all been removed with the exception of St Gregory and St Patrick's. The small, restrained Gothic Revival church building has rendered elevations and a slated roof. The nave has the door to one side as well as a series of pointed windows framed with brick surrounds. The half-octagonal apse projects from the end of the nave and has a range of pointed and round windows on the upper level, in addition to some small commemorative plaques. Internally the building was divided into a small schoolroom and the chapel nave. The nave itself has a wooden sheeted ceiling with exposed wooden beams as well as arched and circular windows. The altar is set into the apse with a wooden panelled backdrop.

48. Library, Catherine Street, 1906

The symmetrical stone-built Catherine Street Library opens directly onto Catherine Street and was built in 1906 with finance from the Andrew Carnegie Trust. This has a central double-storey central block with an attic floor and

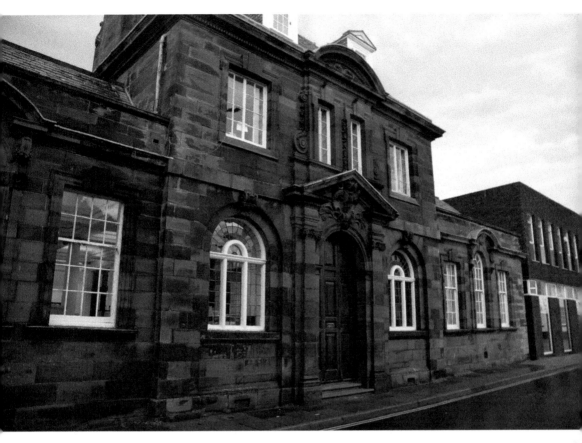

Above: The complex symmetrical neoclassical
elevation of the library building opens
directly onto Catherine Street.

Right: The line of the arched doorcase and
triangular pediment of the library on Catherine
Street extends upwards to the roof, including the
two slim first-floor windows, and terminates with
a cambered pediment at eaves level.

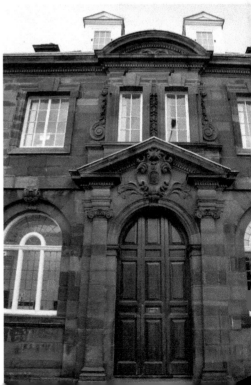

The moulded round-headed windows of the library side wings on Catherine Street have a stepped keystone mounted by a skilfully carved winged angelic face.

single-storey side wings, all richly detailed with Georgian elements. The central block has a panelled door set into a semicircular arched opening. This is flanked by arched windows with rectangular windows on the first floor, while overhead the roof has pedimented dormer windows. The single-storey wings have a slight back step with a central window arranged in a tripartite group. The little group is flanked by side columns with the old Whitehaven coat of arms above the arch, and above this a triangular open pediment. The line of the doorcase is extended to the roof level with a first-floor pair of narrow windows and a cambered, or curved arch, pediment at eaves level. In the side wings the central window of the group is arched while the flanking side windows have standard Georgian sliding sashes. The window openings have moulded architraves and carved keystones. The keystone of the central window is particularly elaborate with the face of a winged angelic figure.

49. Hilary Mews, Catherine Street, 1937

Hilary Mews on Catherine Street was built in 1937 according to the fanlight over the entrance door. The building formally acted as the Whitehaven Job Centre and is now in residential use as part of the housing development immediately behind. The single-storey attractive building is stone faced with an attic storey and flush roof lights in the hipped slated roof. The building has an off-centre arched doorway that opens directly onto the street as well as three arched Georgian windows. These have rounded heads and sliding sashes. The mews also has a potted landscaped strip garden between the building and the street line. Hilary Mews is one of the last Georgian buildings to make an appearance in Whitehaven and can be said to have brought the development of Georgian Whitehaven to a close.

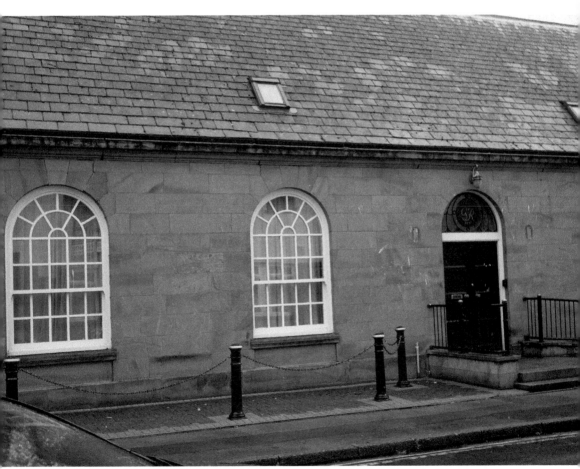

The attractive stone-fronted and slated Hilary Mews has an arched doorway and matching round-headed Georgian windows facing onto Catherine Street.

Hilary Mews has a potted landscaped strip that acts as a small container garden between the house front and the Catherine Street road boundary.

50. New House, Queen Street, 1975

During the refurbishing period of the 1970s it was discovered that some of
the house properties, particularly around Georges Street and Queen Street for
example, were so dilapidated that restoration and conservation would prove
impractical. In these instances it was decided that new builds would be a more
practical approach and these would be laid out in line with the criteria set out
by the original Lowther requirements and so would harmonise with the essential
architectural character of Georgian Whitehaven. The new terraced corner house
on Queen Street, for example, is two storeys high with rendered walling and a
slated roof. The doors, and to a greater extent the window designs, have Georgian
and Victorian proportions with sliding sashes and plain architraves. The three-
storey Duke Street houses within the same development area incorporated a
similar approach. Here the uniform street front with its plain rendering and slated
roofs is repeated. The windows are smaller in scale, but the plain architraves
around the doors and windows are a recurrent feature.

The form and scale of the new two-storey terraced house on Queen Street harmonises with
the overall character of Whitehaven's Georgian terraced housing.

Also by the Author

Exploring Georgian Dublin (2008)
Exploring Ireland's Historic Towns (2010)
Exploring Irish Castles (2011)
Exploring Celtic Ireland (2011)
Exploring Georgian Limerick (2012)
Georgian Bath (2012)
Georgian London: The West End (2012)
The Georgian Town House (2013)
Edinburgh New Town, co-authored by Carley, Dalziel and Laird (2015)
Dublin in 50 Buildings (2017)
Bath in 50 Buildings (2018)
Dublin Pubs (2018)
Limerick in 50 Buildings (2019)
Kilkenny: City of Heritage (2019)